CowParade
NEW YORK

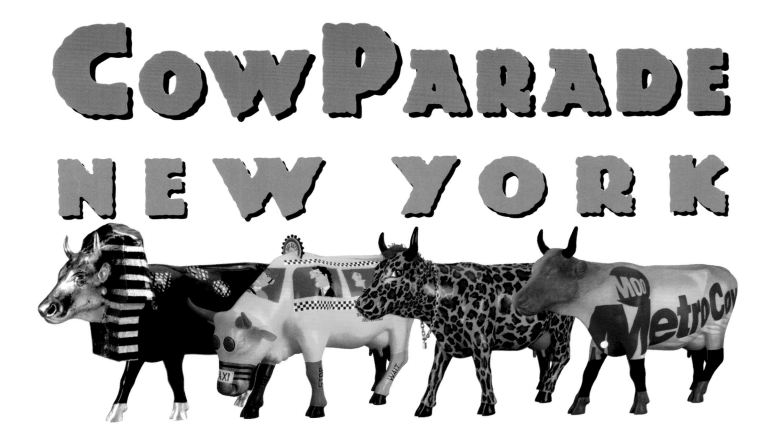

WORKMAN PUBLISHING • NEW YORK

Text written by Thomas Craughwell

Photography credits appear on pages 147 and 148
Cover background photography by Albert Normandin/Masterfile
Cover cow photograph by Schecter Lee

Library of Congress Cataloging-in Publication Data is available

ISBN 0-7611-2263-X (pbk.) • ISBN 0-7611-2264-8

CowParade is a registered trademark of CowParade Holdings Corporation

Visit the CowParade website at www.cowparade.net

Workman books are available at special discounts when purchased in bulk for
premiums and sales promotions as well as for fund-raising or educational use.
Special editions or book excerpts can also be created to specification.
For details, contact the Special Sales Director at the address below.

Workman Publishing Company, Inc.
708 Broadway
New York, NY 10003-9555
www.workman.com

Printed in the United States of America

First printing July 2000
10 9 8 7 6 5 4 3 2 1

TABLE OF CONTENTS

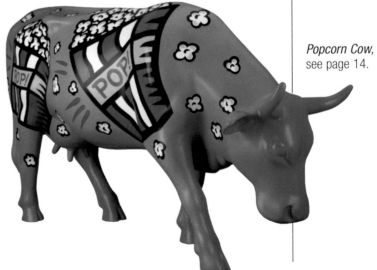

Popcorn Cow,
see page 14.

LETTER FROM THE MAYOR

Dear Friends:

Throughout the summer, CowParade New York 2000 will grace the city's parks and plazas with over 500 colorful cows, all painted and decorated by talented New York artists. Now New Yorkers and visitors have one more reason to explore the canyons and pastures of New York and graze in the incredible cultural delights our city has to offer.

CowParade New York 2000 represents collaboration by the New York arts community, city government, and corporate sponsors, proving once again that wonderful things can be accomplished when New Yorkers work together. Our magnificent herd will not only enrich the New York experience, but will also benefit New York City charities.

Enjoy this unique public art exhibition.

Sincerely,

Rudolph W. Giuliani
Mayor

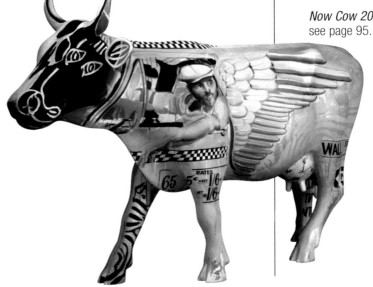

Now Cow 2000,
see page 95.

INTRODUCTION

Welcome to CowParade New York 2000. What you will see on the following pages are the spectacular creations of hundreds of artists who participated in this memorable event. Some of these are the works of preeminent artists; others the labors of aspiring or student artists. Altogether, more than 500 original works of art were created for exhibition in a variety of public and private venues. CowParade New York 2000 marks the first time a public art event has been staged simultaneously in all five boroughs of New York City.

One of the most rewarding and interesting elements of the event is a program involving the New York City public schoolchildren. With BASF Corporation generously underwriting the cost, 50 cows—40 for students and 10 for teachers—were promised to New York City public schools. Under the direction of Dr. Sharon Dunn, Senior Assistant for the Arts, the winning designs were chosen from more than 200 submissions. I had the opportunity to be present at the Board of Education warehouse in Queens where all of the completed school cows were assembled together with the kids who painted them. These young students radiated a sense of pride and accomplishment that affected everyone present. One of the primary objectives of CowParade is to foster art and art programs in the schools, as we strongly believe that art helps schoolchildren better understand and relate to their environments, encourages the development of creative skills, and builds self-confidence. What I saw and felt that day in the Board of Education building confirmed these beliefs and the success of our student program.

Why the cow? It is simply a unique, three-dimensional canvas to which the artist can easily relate. There is really no other animal that can adequately substitute for the cow

and produce the level of artistic accomplishment evident in this book. The surface area and bone structures are just right, as well as the height and length. Even more importantly, the cow is an animal we all love. One of the first words most of us say in our infancy is "moo." Cows provide the milk that fosters our development, and milk is the basis of beloved childhood treats like ice cream. The cow is whimsical, quirky, and never threatening. That is why so much of the art in this show causes us to laugh, smile, and just feel good.

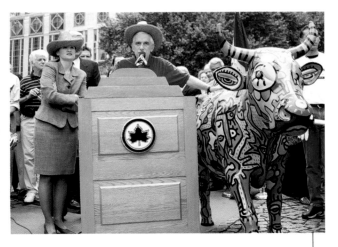

I thank all the artists who participated in this undertaking and the many corporate, business, and individual patrons whose sponsorships helped underwrite the cost of the exhibit. Nothing would have been possible without the support of the great City of New York, Mayor Giuliani, and with special note, Henry Stern, the Commissioner of the Parks Department, who encouraged me and Peter Price to bring CowParade to New York City.

Jerry Elbaum
President, CowParade Holdings Corporation

THE BIG BOVINE
A History of Cows in New York

Cows in New York? You might as well expect dolphins in Des Moines. Or elephants in Indianapolis. Abilene is a cow town. Kansas City is a cow town. Fort Atkinson, Wisconsin, home of the National Dairy Shrine, is most definitely a cow town. But at first glance, New York, with its noise, crowds, and concrete, just doesn't seem very bovine friendly. Nonetheless, for a few happy weeks, New York will host a stampede of colorful cattle known as CowParade. And in many ways, New York is a happier site for the CowParade than Chicago, the first American city to host the parade.

Who are the famous cows of Chicago? There's Mrs. O'Leary's cow, who kicked over a kerosene lamp and started the Great Chicago Fire. And then there are the herds of cattle that were, shall we say, "processed" in the stockyards. Does this make for happy history on the hoof? I don't think so.

In New York, however, cows are a reminder of the city's distant bucolic past. The first huddled mass of Holsteins arrived in New Amsterdam in 1625. A document from the period, written by Jonas Michaelius, tells us that dairy products were hard to come by in the Dutch colony, so every immigrant cow was welcome. By 1644 the local herds inside the settlement were considerable, and it wasn't unusual to find cows that had strayed from the pastures of

The Bovine Timeline

c. 3000 B.C.
Queen Hete-Phere of Egypt accepts the honorary title "Guardian of the Corporation of Butchers."

c. 4000 B.C.
The first cheese is made in Switzerland.

c. 500 B.C.
Darius, a Persian gourmand, gives the first banquet in which the main course is a roasted whole ox.

c. 850
Vikings bring the ancestors of British White cattle to England.

1029
The Norse king Sitric hands over 1,200 cows to ransom his son, Olaf.

c. 5000 B.C.
Farmers in Greece, Turkey, and Crete start domesticating wild cattle.

c. 3500 B.C.
Butter is invented in Sumeria.

c. 2000 B.C.
When three angels appear at Abraham's tent, he serves them butter, milk, and a fatted calf.

c. A.D.100
An anonymous poet creates *The Tain,* Ireland's national epic about a war that started over a cattle raid.

960
Monks from Brittany introduce the first dairy cows to the island of Guernsey.

1493
The first cattle in the New World come ashore with Christopher Columbus on the island of Hispaniola.

1521
The first longhorn cattle arrive in Mexico with Cortés.

Battery Park wandering up and down Broadway. To keep the wandering cows in (and the hostile Indians out), the Dutch built a wall along what is now Wall Street.

The New Amsterdam years were a golden age for cows. Every morning the herdsmen walked through the streets of Lower Manhattan, blowing horns to summon the cows and lead them to graze in the lush meadows around City Hall. In the evening they delivered them back to their owners, ready to be milked.

Of course, not everyone in Old New York owned a cow. But the people who did made a nice business of bartering their excess milk, butter, and cheese with their nondairying neighbors.

There must have been a surplus of dairy products in the city during the American Revolution, because that is when ice cream first appeared in New York. It was a huge hit. In 1779, as demand increased, an entrepreneur named Joseph Corree offered home delivery of ice cream. By the 1840s, men were wandering through the streets selling ice cream from small wagons pulled by goats.

In the early 1800s, as farmland became scarce in Manhattan, dairy farmers moved their herds to Brooklyn and Queens. For the first time milkmen appeared in New York, walking

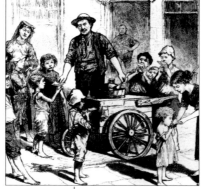

I Scream, You Scream

This sketch of an ice-cream man and his clientele made in the early 20th century proves that some things never change. Ice cream was as popular with children then as it is now.

1611
The first cows in English North America arrive at Jamestown.

1625
The first Holstiens arrive in New Amsterdam.

1653
The Dutch use the meadows around City Hall as the summer pasture.

1779
Joseph Corree of New York City begins home delivery of ice cream.

1840
Goat-drawn ice-cream wagons make the rounds in the city.

1850
New York and Erie railroad carries over 13 million gallons of milk into the city in one year.

1570s
Every Sunday afternoon, Queen Elizabeth I of England attends a bull- or a bear-baiting.

1624
Devon cattle arrive at Plymouth Colony.

1638
A cattle market opens on the site of Bowling Green Park.

1675
Ice cream is introduced in New York.

1800
The first milkmen make deliveries on foot in New York City.

1846
The first cattle drive on record travels from Texas to Missouri.

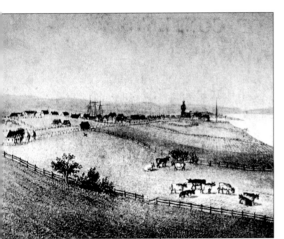

New York City Farms

This print from 1697 shows the cows of New York City grazing by the North River.

through the city with two buckets of milk suspended from a yoke over their shoulders. It was picturesque but not very efficient. Nor could it keep up with demand.

The first attempt at mass production of milk in Manhattan came in the 1820s with the introduction of a product given the unappetizing name "swill milk." For $5 a year, cattle owners rented stalls in sheds and barns attached to breweries and distilleries where the cows were fed brewer's grain, mash, and the swill from the stills. Naturally, savvy New Yorkers would not buy anything in which the word "swill" featured prominently, so the swill milk producers labeled their product "pure country milk." Observant consumers noticed that this "pure" drink had a peculiar bluish tint to it.

Giving swill milk a run for its money was authentic "pure country milk" from farms north of the city. One enterprising dairy owner from Fordham in the Bronx made a small fortune when he started sending his farm-fresh milk down the East River on a large flatboat. In 1842 the New York and Erie railroad introduced the first ice-cooled cars for shipping milk; by 1850 the railroad was carrying over 13 million gallons of milk a year into the city. In response to

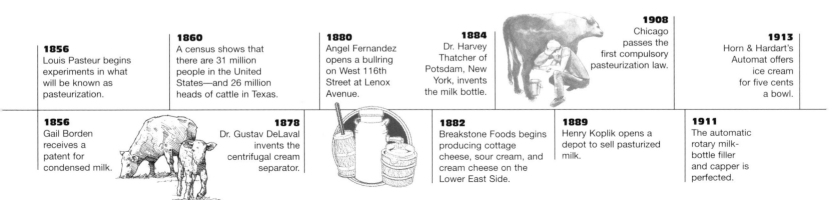

1856
Louis Pasteur begins experiments in what will be known as pasteurization.

1860
A census shows that there are 31 million people in the United States—and 26 million heads of cattle in Texas.

1880
Angel Fernandez opens a bullring on West 116th Street at Lenox Avenue.

1884
Dr. Harvey Thatcher of Potsdam, New York, invents the milk bottle.

1908
Chicago passes the first compulsory pasteurization law.

1913
Horn & Hardart's Automat offers ice cream for five cents a bowl.

1856
Gail Borden receives a patent for condensed milk.

1878
Dr. Gustav DeLaval invents the centrifugal cream separator.

1882
Breakstone Foods begins producing cottage cheese, sour cream, and cream cheese on the Lower East Side.

1889
Henry Koplik opens a depot to sell pasturized milk.

1911
The automatic rotary milk-bottle filler and capper is perfected.

the milk boom, Manhattan milkmen retired their buckets and yokes and made their deliveries from horse-drawn carts.

But the nasty swill milk did not go away and became a health problem throughout the 19th century, especially for residents of the city's poorest neighborhoods. Then in 1889, Henry Koplik opened a milk depot that sold pasteurized milk for infants. Henry L. Coit followed with depots that sold milk certified as pure. And from his factory on the East Third Street Pier, Nathan Strauss sold what he called sterilized milk.

With the arrival of the 20th century, dairy farms began to disappear from New York City. The 1940 census found six farms with 328 cows in Brooklyn, nine farms with 563 cows in Queens, and nine farms with 127 cows on Staten Island. By 1978, there was only one farm in Queens and one on Staten Island.

While New York City may have lost its historic role as a cow town, New York State is still holding its own, cow-wise. It ranks third (after Wisconsin and California) in number of milk cows and third (after Wisconsin and Minnesota) in cheese production. But when it comes to cow-merce, nobody can touch New York. Since 1991 Wall Street has been enjoying the strongest bull market in American history.

1920
The New York Holstein Association is founded to promote and improve the Holstein breed.

1933
Four Guernsey cows make the trip to Antarctica with Admiral Richard Byrd.

1942
Daniel Carasso and Jaun Metzger start Dannon Yogurt in the Bronx.

1991
Wall Street begins what will prove to be the longest bull market in American history.

1919
Torrington, Connecticut, becomes the first town in America to sell homogenized milk.

1929
Walt Disney's Clarabelle Cow makes her debut in the animated cartoon *The Plow Boy*.

1938
Bulk tanks begin to replace the old milk cans.

1948
Plastic-coated paper milk cartons are introduced.

1978
Only two dairy farms remain in Queens and on Staten Island.

1993
Big Bertha, a Dremon cow, dies at age 48 years and nine months. She was the oldest cow on record.

A COW IS BORN
Susie Perelman's Udderly Mysticow

While traveling in Southeast Asia, Susie Perelman discovered the paradox of cows: "On the one hand they are mundane. They are used for labor, so they're the lowest of the low. But they're also sacred, so they are the highest of the high."

Using over 50 photographs that she took in Asia, Perelman played with the scale and perspective of her images to come up with what she describes as "a blend of photographic truth and painterly reinvention."

Because her studio was too small to accommodate a life-size fiberglass Holstein, Perelman moved to an empty floor of an office building. It was a cavernous space, but she was never lonely. People who worked on the other floors dropped by every day to see her, and as they watched the work in progress they chatted about cows.

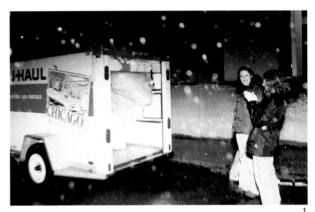

1

"It's a funny thing," Perelman said. "These cows enable people to talk to each other about art and life. Maybe it's because of the positive things cows represent. They're milk and nurturing and 'down on the farm.'"

Perelman documented every phase of *Udderly Mysticow's* birth, from her arrival at the studio to finished cow.

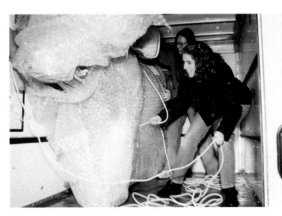

1. A U-Haul truck delivers the cow to Perelman's studio.

2. The cow is unwrapped.

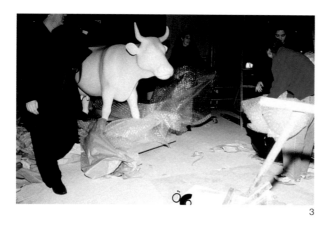

3

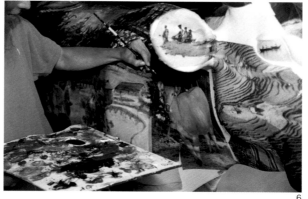

6

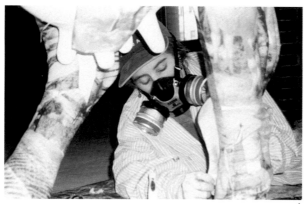

4

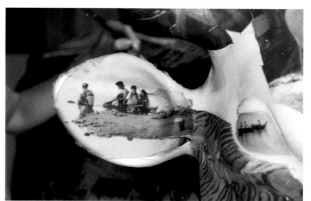

7

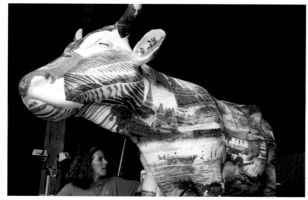

5

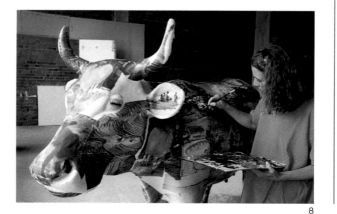

8

3. A naked bovine emerges from the wrappings.

4. Perelman glues the photographic images to the cow. She used strong adhesives so she wore a mask.

5-7. Perelman painting her cow.

7. A detail of the ear.

8. Perelman puts on the finishing touches.

DOWNTOWN

You Are Here Cow

Artist: Eudora (Jay)
Jeserum
Patron: Prudential
Securities
Location: One New York
Plaza (next to Battery Park
and the Staten Island Ferry)

downtown—by which we mean all addresses south of Greenwich Village—is the birthplace of New York. It was here that Manhattan was purchased from Native American inhabitants in 1624 for the equivalent of $24. It was here that the nation's most influential stock market was established in 1817. And it was here, at the very tip of the island, that many of the huddled masses who transformed American immigration first breathed free.

Cows played an important part in the character of old New York. The first cattle market was established in 1638 at Bowling Green, and America's first restaurant, Delmonico's, was opened on William Street in 1827. Unfortunately, it was a steakhouse.

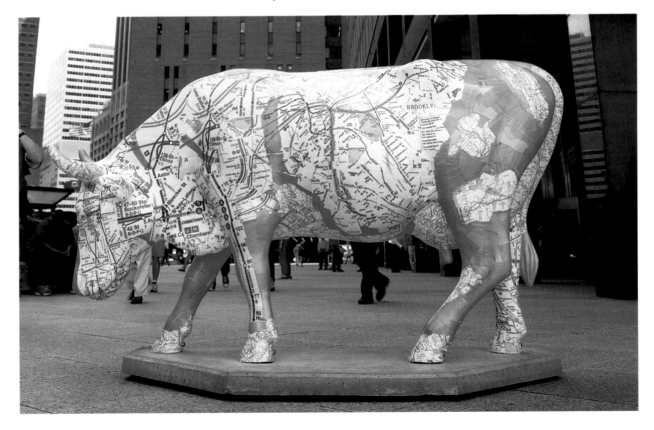

KEY COW FACTS

The average life span
of a cow is 25 years.

Battery Park

Battery Park is New York's Plymouth Rock—it's the jumping-off point for the settlement of the city. The first Dutch colonists, the first Dutch cows, in fact, the first of everything came ashore here. Today, with its spectacular views of the harbor, the Statue of Liberty, and the skyline of Lower Manhattan, the Battery is one of New York's most popular parks.

The park is built entirely on landfill. Originally, Whitehall Street ran directly along the waterfront, and Castle Clinton, the red sandstone fort where you line up to buy tickets for the Statue of Liberty and Ellis Island, was 100 yards off shore. As early as the 18th century, New Yorkers were busying themselves extending the shoreline of Manhattan. Among the materials they used for the landfill were the stones from the old Dutch Fort Amsterdam.

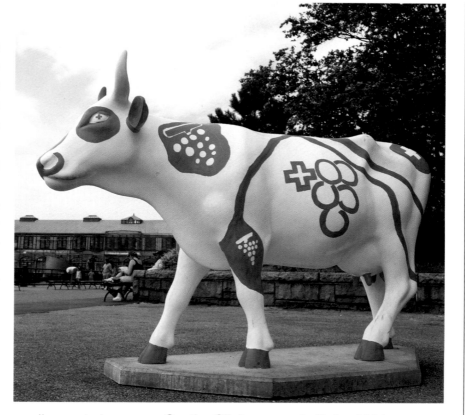

Swiss Wine

Artist: Nicholas Leonard
Patron: Swiss Wine Exporters' Association (SWEA)
Location: Battery Park

Castle Clinton was built in 1811 as part of the defenses of New York Harbor, but it never saw any military action. After a life as a concert hall, an immigration center, and an aquarium, the castle was scheduled for demolition. Only a very loud and sustained public outcry over the loss of the fort and the park saved them from demise.

**The Sounds
of Moosic**
(top left)

Artist: Gary Golio
Patron: Borders Books
& Music
Location: Borders store
at 5 World Trade Center

**New York State
of Cow**
(top right)

Artist: Victor Teng,
art teacher of PS 181,
School District 17
Patron: BASF
Location: Battery Park,
across from 17 State Street

Jet Set Tony
(bottom)

Artist: Kuo Chih Hung
Patron: US Airways
Location: 5 World Trade
Center Plaza

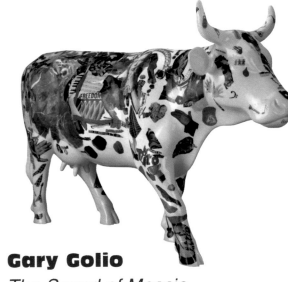

Gary Golio
The Sound of Moosic

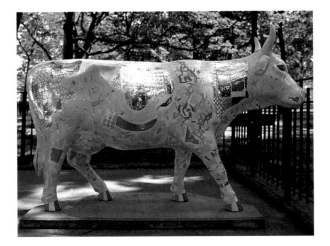

"New York City," says Gary Golio, "is a place where art is sometimes taken too seriously."

Golio decided to celebrate his passion for music. He anchored each side of the cow with large images of some of his musical heroes: Elvis, Joni Mitchell, Diana Ross. But he didn't want it to be a collage of people's faces, so Golio added colors and textures.

"With the first side I nailed it," Golio said. "It went together beautifully. But the second side—boy, was that a disaster!" Twice Golio scraped off his collage on side two before he finally achieved what he was looking for.

"The project had its hairy moments," he said. "And I knew I couldn't go ask for another cow."

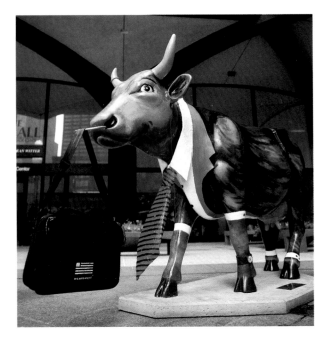

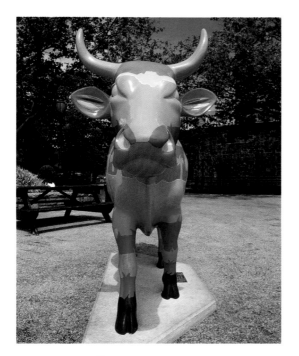

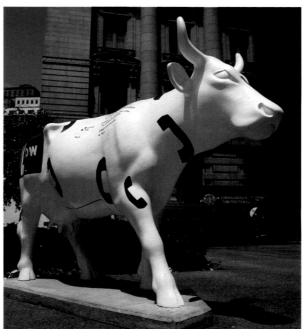

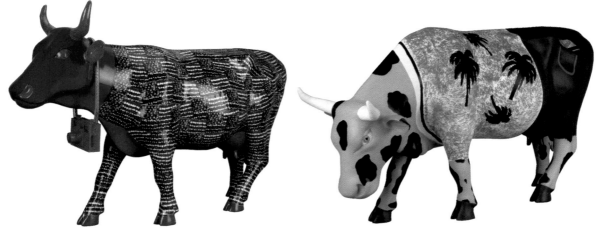

Tropicow
(top left)

Artist: Edwin G. Cadiz
Patron: Bahamas Ministry of Tourism
Location: Battery Park

Cow Friend's Network
(top right)

Artist: Jason Dean
Patron: The State-Whitehall Co., Rose Associates
Location: One Battery Park Plaza (at Pearl and State Streets)

American Flower Power Photo Cow
(bottom left)

Artist: Susumu Sato
Patron: CowParade New York 2000, Inc.
Location: Battery Park

Tourist Cow
(bottom right)

Artist: Shakir Swaby of Graphic Communication Arts High School, Manhattan
Patron: BASF
Location: Battery Park

The Twin Cowers

Artist: Silk Fish Design, Inc.
Patron:
OppenheimerFunds, Inc.
Location: World Trade
Center, Tobin Plaza

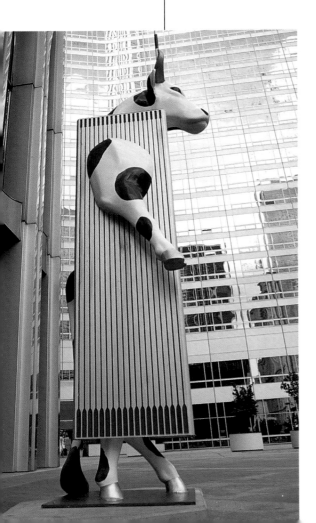

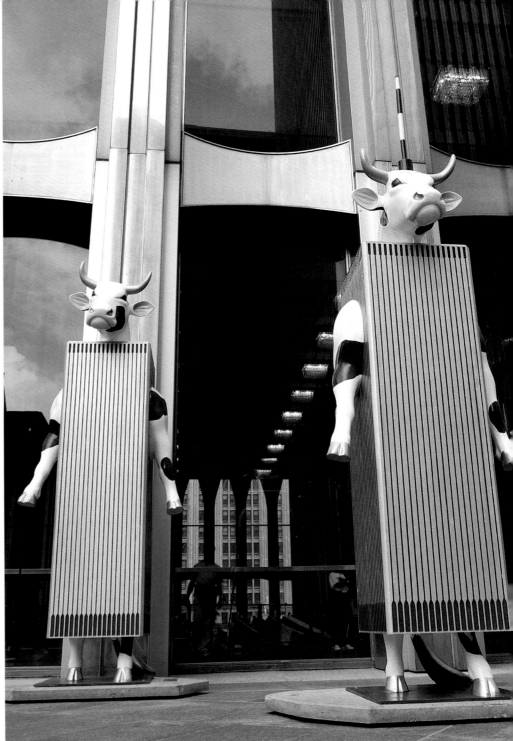

Bullish on Wall Street

It makes sense that the bull that should be the totem of the most aggressive neighborhood in New York City. Around the world Wall Street is synonymous with America's financial and economic muscle. Since 1990, the bulls of Wall Street have been enjoying a run the likes of which has not been seen since the boom that followed the first World War.

Legend says that the New York Stock Exchange began under a buttonwood tree in 1792. It's true that 27 New York stockbrokers and merchants agreed to form a stock exchange that year, but it didn't last long. The bankruptcy of financier William Duer started the first financial panic in the city's history. New York's securities market collapsed and remained pretty inactive until 1817 when a new New York Stock Exchange was founded.

Of course, there's more to Wall Street's story than making money. At the head of Wall Street stands Trinity Church. There has been a house of worship on this site since 1698 (the current church building was completed in 1846). In the churchyard are the tombs of Alexander Hamilton, Robert Fulton, and Francis Lewis, a signer of the Declaration of Independence. The churchyard also pre-serves America's earliest Tomb of the Unknowns: The Martyrs' Monument honors unidentified patriots who died on British prison ships during the Revolution.

Under the terms of the royal charter that established Trinity Church in 1697, the congregation agreed to pay the British crown an annual rent of one peppercorn. When Queen Elizabeth II of England visited Trinity Church in 1976 during America's bicentennial celebrations, she was presented with 279 peppercorns for the 279 years of back rent the church owed its landlord.

Live Stock

Artist: The creative team at the NBC Agency
Patron: CNBC/cnbc.com
Location: Bowling Green, at the Wall Street bull

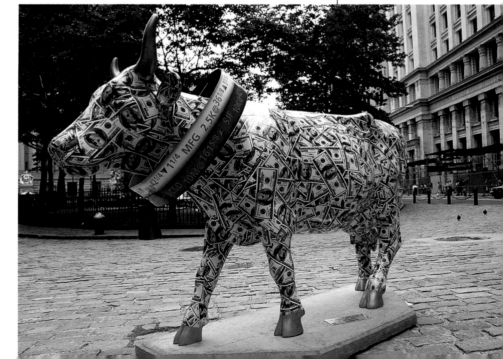

Herd on the Street I: Moola, the Cash Cow
(top left)

Artists: Barbara Edelstein and Jian-Jun Zhang
Patron: The Wall Street Journal
Location: 23 Wall Street

Herd on the Street II: Blue Moo-n
(right, top and bottom)

Artist: Cynthia Mailman
Patron: The Wall Street Journal
Location: 23 Wall Street

Herd on the Street III: Ella Mae, the Cow Cow Boogie Cow
(bottom left)

Artist: Richard Isaacs
Patron: The Wall Street Journal
Location: 23 Wall Street

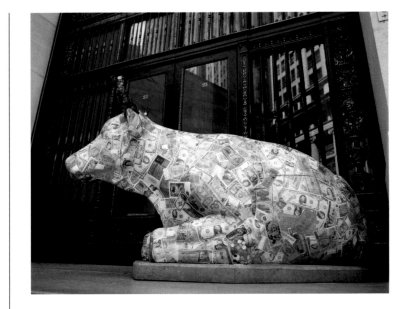

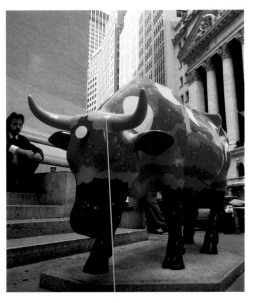

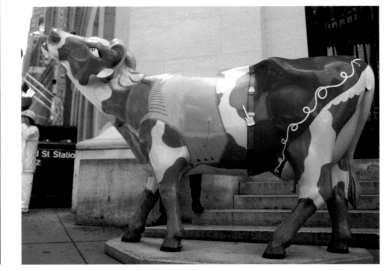

South Street Seaport

Two hundred fifty years ago, newcomers to New York City landed at the South Street Seaport on the East River. One has to wonder what those early immigrants thought of New York as they made their way past a legion of saloons and brothels through one of the rowdiest neighborhoods in town.

Despite its rough edges, the neighborhood has had its share of literary associations.

Jimmy the Priest's Saloon, a notorious flophouse, once stood on Fulton Street. The future playwright Eugene O'Neill was a regular, and he set two of his dramas, *The Iceman Cometh* and *Anna Christie,* in Jimmy's saloon.

Around the corner on Nassau Street was the home of doomed Mary Rogers, a pretty young woman who worked in a cigar shop. One of her customers, Edgar Allan Poe, based his "Mystery of Marie Roget" on the unsolved murder of this attractive salesgirl.

Yahoo! MooMail

Artist: Amy Armock
Patron: Yahoo!
Location: South Street Seaport

KEY COW FACTS

In every herd, there is one bull for every 30 cows.

Cowabunga

Artist: Silvestri California
Patron: Silvestri California
Location: South Street
Seaport

**RECORD-
SETTING
COWS**

The Tallest Cow:
Chianina; stands
six feet high.

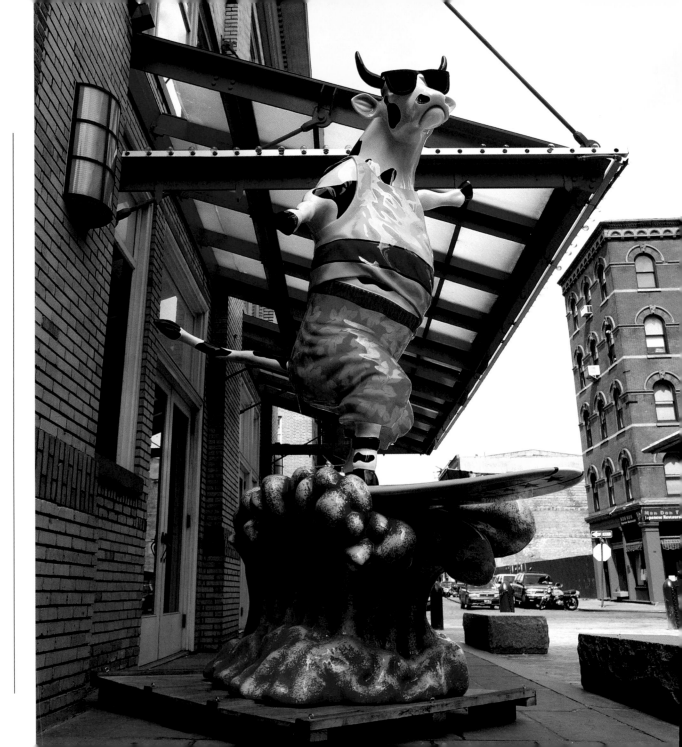

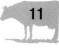

City Hall Park

Historically speaking, City Hall is Cow Central. In the 17th century, this is where the Dutch pastured their cattle. In the years since then, the wagon wheels that accompanied the cows have been replaced by the wheels of justice. Sometimes, especially after a press conference, you can still catch a whiff of fresh manure.

New York's first city hall back in 1653 was a tavern on Pearl Street near Coenties Slip. In 1703, a proper city hall building was erected on Wall Street. It saw a lot of action. Peter Zenger's famous freedom of the press trial was held here in 1735. Aggrieved Americans met here in the Stamp Act Congress in 1765 to protest "taxation without representation." The French architect Pierre L'Enfant redesigned the building in 1788 and it was christened Federal Hall. New York's current City Hall was begun in 1802.

A block away from City Hall is the notorious Tweed Courthouse. Initial estimates for the building in 1858 came in at $250,000. By the time Tammany Boss William Tweed and his cronies got through with the project, the grand building had cost New York taxpayers nearly $13 million!

COW LORE

If a cow stands with her back to the wind, it's about to rain.

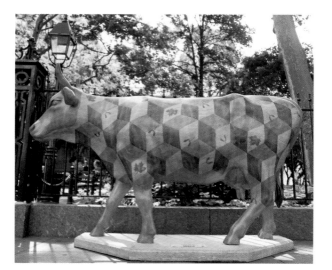

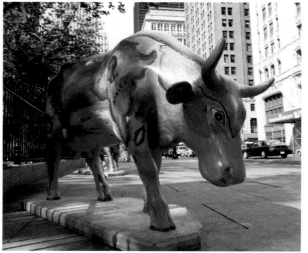

Udderly Wooden
(left)
Artist: Mary Beth Whalen
Patron: Bank of America
Location: City Hall Park

World Immigrants Milk Big Apple?
(right)
Artist: Class 601 of CS 61, School District 12
Patron: BASF
Location: City Hall Park

Greenhorn in the City
(top left)

Artist: Gigi Horr Liverant
Patron: Anonymous
Location: City Hall Park (between Park Row and Broadway)

Dottie
(top right)

Artist: Joseph McElroy
Patron: everydayoffice
Location: City Hall Park (between Park Row and Broadway)

Harbor Park
(bottom)

Artist: Robert J. Sievert
Patron: Willis of New York, Inc.
Location: Hanover Square

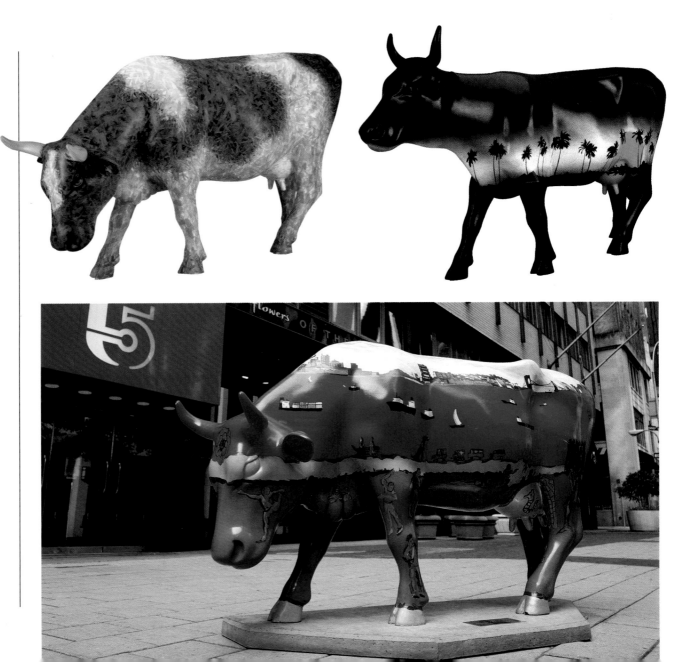

Pamela Stockamore
Roebling Wire Rope Cow

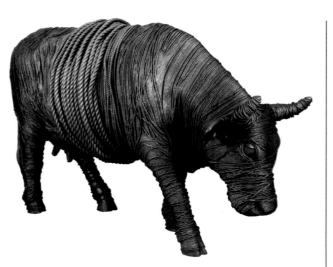

Roebling Wire Rope Cow

Artist: Pamela Stockamore
Patron: CowParade New York 2000, Inc.
Location: City Hall Park

Nineteen years ago Pamela Stockamore took her first walk across the Brooklyn Bridge. Although for most pedestrians a stroll across the bridge can be measured in minutes, Stockamore's walk took several hours. "I kept stopping, marveling at this thing of grace and beauty," she said.

Stockamore's *Roebling Wire Rope Cow*— a cow wrapped entirely in rope, then painted to resemble the steel cable used on the Brooklyn Bridge—is a salute to one of her favorite walks and to the Roebling family who built the bridge.

Of course, proposing to wrap a fiberglass cow in "steel" cables is one thing; executing it is another. "Doing a sketch in two dimensions," Stockamore said, "is not the same as applying something three dimensional (the rope) to an object that is also three dimensional (the cow)."

By working slowly—quarter inch by quarter inch—she managed to get the rope to adhere to the cow's surface "like a tight sweater," so the contours of the beast would come through the cable.

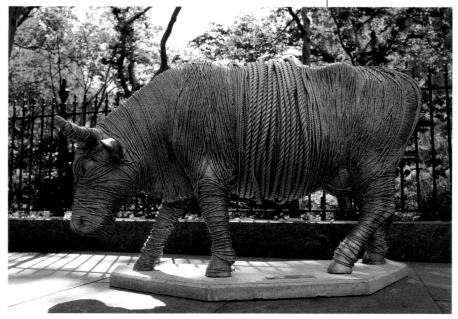

Cow Hands
(top left)

Artist: Edwina Sandys
Patrons: SoHo and
TriBeCa Partnerships
Location: Houston Street
Mall (between Broadway
and West Broadway)

Tied to N.Y.
(top middle)

Artist: Jennifer Kapnek
Patron: United Paramount
Network
Location: Soho Square

Butterfly Cow
(top right)

Artist: Romero Britto
Patron: Nan Miller Gallery,
Rochester, New York
Location: Duarte Square
(Canal Street at Avenue
of the Americas)

Popcorn Cow
(bottom)

Artist: Burton Morris
Patron: CowParade
New York 2000, Inc.
Location: Pop International
Gallery (West Broadway
at Houston Street)

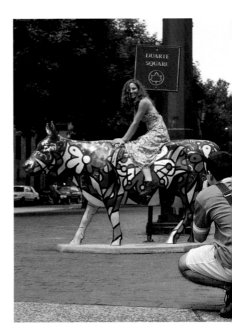

SoHo Cows

Short for South of Houston, SoHo is known for its high concentration of art galleries and artists' studios. Once a neighborhood of manufacturing spaces, many of the commerical buildings have been converted to elegant loft apartments with soaring ceilings and open layouts. The commerce in SoHo these days is focused on the chic retailers and restaurants that draw throngs on the weekends.

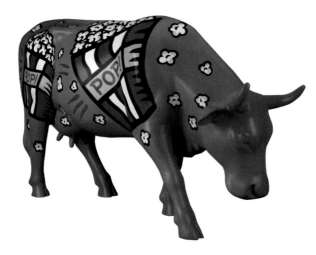

Greenwich Village

For nearly 200 years, Greenwich Village was a bucolic retreat for New Yorkers who wanted to escape the noise, heat, and congestion of Downtown. True to its name, Greenwich Village really was a rural hamlet surrounded by small farms. Although today no one would describe the Village as rural, it is distinct from the rest of Manhattan. Its narrow, tree-shaded streets and beautiful 19th-century brick houses make it a kind of Old World oasis. By the way, although the Village has a long-standing reputation as a bohemian neighborhood, it's been years since any bona fide bohemian could afford Village rents.

For all its pastoral past, the Village has a distinguished literary pedigree. Edgar Allan Poe wrote "The Raven" while living on West 3rd Street. Henry James was born on Washington Place and based the setting of his novel *Washington Square* on his grandmother's fine house on Washington Square North. The Cedar Tavern was a favorite watering hole for Jack Kerouac, Allen Ginsberg, Frank O'Hara, and Gregory Corso. At one point, Marianne Moore, Sherwood Anderson, and Theodore Dreiser were neighbors on St. Luke's Place. Edna St. Vincent Millay lived around the corner on Bedford Street and e e cummings and Djuna Barnes were shouting to one another through their windows on Patchen Place.

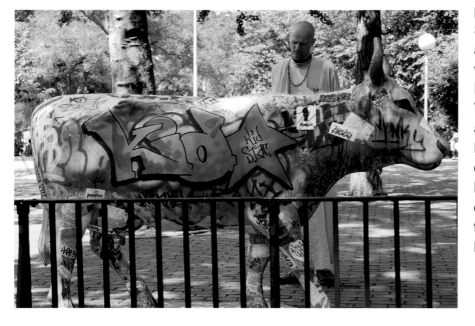

Graffiti Cow

Artist: Hope169
Patron: Time Inc. Custom Publishing
Location: Washington Square Park

Cattle Car
(top left)

Artists: C. Bissell,
E. Maertens, and
M. Schachner
Patron: Lowe, Lintas,
and Partners
Location: Washington
Square Park

*Fake for the
Animal's Sake*
(top right)

Artist: Jerard Studio
Patron: PETA
Location: Washington
Square Park

City Life
(bottom left)

Artist: Jenny M. Steinman
Patron: Emigrant Savings
Bank
Location: Wittenberg Triangle
(Greenwich Avenue and
Christopher Street)

Mukki
(bottom right)

Artists: Chris Rubino
and Ami Werner
Patron: CowParade
New York 2000, Inc.
Location: Jefferson Market
Garden (Avenue of the
Americas at 10th Street)

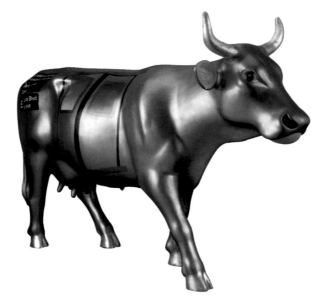
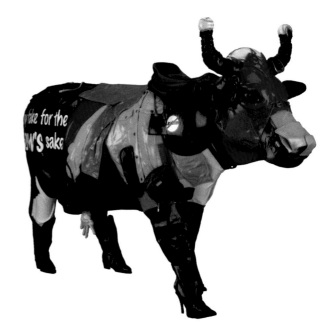
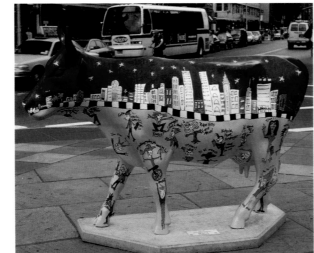

Kimble Mead

Brain Quest Cow

Kimble Mead has been the illustrator for Workman Publishing's blockbuster educational series, Brain Quest, for nearly ten years. So when Workman decided to sponsor a cow for CowParade, Mead was the artist they wanted.

"I'm quite fond of cows," Mead said. "I grew up in Massachusetts where I saw lots of them. And I collect postcards of cows. But I've never had a close personal relationship with a cow until now."

As a painter and illustrator, Mead is accustomed to painting flat surfaces. "I don't have much experience painting three-dimensional objects," he said, "although once my Brain Quest illustrations were blown up and mounted on a bus."

Mead thought he'd like his cow to be a cartoon figure, so in addition to exaggerating the cow's eyelashes and lips, he had the trademark Brain Quest kids looking out of portholes along the cow's side.

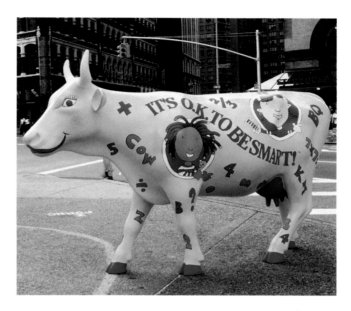

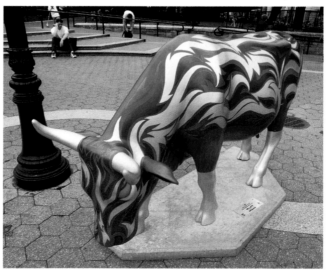

Brain Quest Cow
(top)
Artist: Kimble Mead
Patron: Workman Publishing Company, Inc.
Location: Union Square Park (pictured here at Astor Place)

.COW
(bottom)
Artist: MSG A & D
Patron: Media Metrix
Location: Union Square Park

Con Edna
(top left)

Artists: Barbara Pucci and students from Teachers & Writers
Patron: Con Edison
Location: Union Square Park

Toy Cow
(bottom left)

Artists: Jim Ryan and Kiddie Ride
Patron: Toys 'R' Us Children's Fund
Location: Union Square Park

Bookmark Cow
(right)

Artist: TBWA/CHIAT/DAY
Patron: barnes&noble.com
Location: Union Square Park

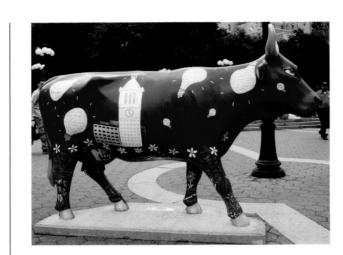

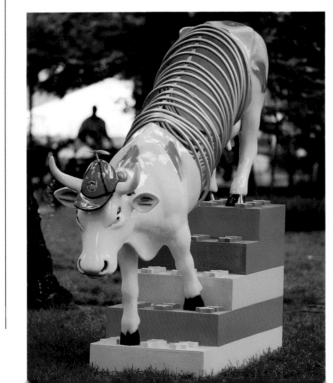

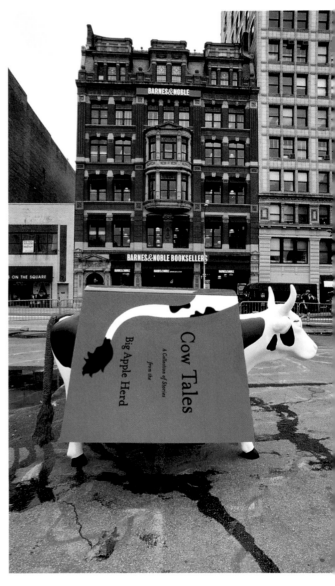

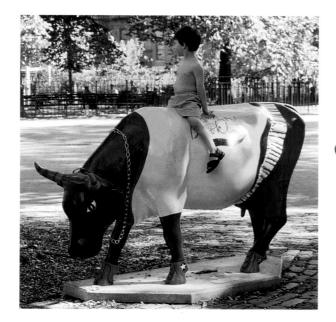

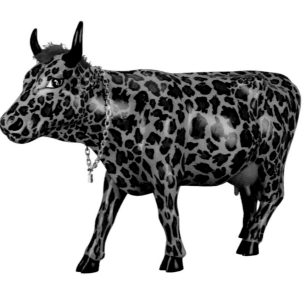

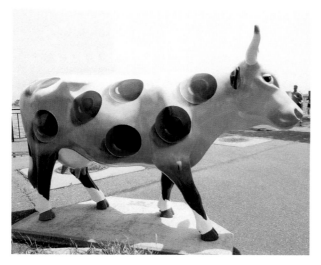

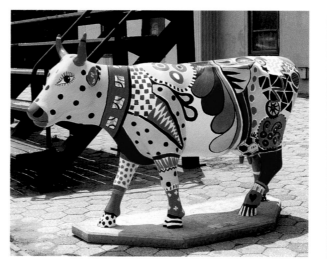

Hip Hop Moosic
(top left)

Artists: Smokeshop Recording Studio/ Lisa di Prima
Patron: Cow Parade New York 2000, Inc.
Location: Tompkins Square Park

Punk Rocowa
(top right)

Artist: Janine Gordon
Patron: United Paramount Network
Location: Tompkins Square Park

The Uncow Ordinated Bowlvine
(bottom left)

Artists: Kathryn Frund and Steve Whinfield
Patron: CowParade New York 2000, Inc.
Location: East River Park

Kick
(bottom right)

Artist: Garance
Patron: Swiss Soccer Club
Location: East River Park

MIDTOWN

KEY COW FACTS

Nobody on the planet eats more butter than New Zealanders, who consume 26 pounds per person each year. In the United States, however, butter consumption is spread pretty thin—only four pounds per person each year.

*Cow-lder
for the Mooseum
of Modern Art
(MOOMA)*

Artist: Peter Ketchum
Patron: PaineWebber
Incorporated
Location: 1285 Avenue
of the Americas
(at 52nd Street)

midtown is the heart of New York City. In the area between 59th Street and 34th Street you'll find most of New York's publishing houses and advertising agencies, media and entertainment giants such as Time Warner, the lion's share of the city's hotels (including the Waldorf-Astoria, Peninsula, and Plaza) and stores whose names are recognized around the world (including Saks, Tiffany's, and Cartier). Because this neighborhood has such a high concentration of famous New York landmarks—Times Square, Radio City Music Hall, the Empire State Building, the Chrysler Building, the Museum of Modern Art, the United Nations, St. Patrick's Cathedral, Grand Central Station—Midtown draws more tourists than any other part of town.

The landmarks of Midtown also attract camera crews. Ever since King Kong scrambled to the top of the Empire State Building with Fay Wray in his big hairy hand, Midtown has been a favorite location for filmmakers. From *Miracle on 34th Street* to *The Godfather,* from *Radio Days* and *Annie Hall* to *Tootsie,* from *Mean Streets* to *Taxi Driver,* movie makers have had a long-standing love affair with Midtown Manhattan.

St. Patrick's Cathedral, by the way, has been the setting to a host of real-life dramas. F. Scott Fitzgerald and Zelda Sayre were married in the cathedral on Easter Sunday, 1920. Babe Ruth's funeral Mass was said here in 1948. And in 1965, Pope Paul VI came to the cathedral to pray on the first papal visit to the United States.

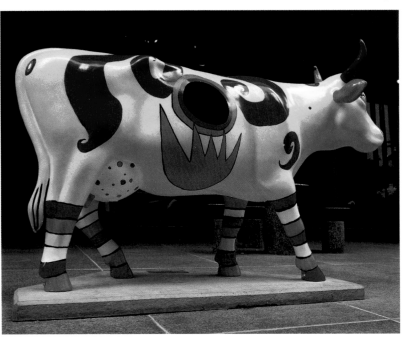

The Fifties

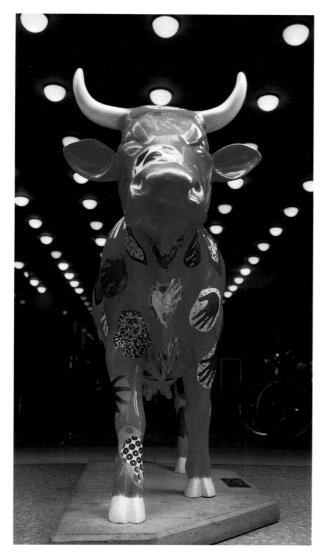

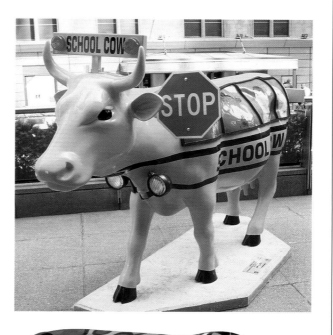

Collaborative Hand Quilt
(left)

Artist: Josette Urso
Patron: PEOPLE Magazine
Location: 1271 Avenue of the Americas (at 51st Street)

School Cow
(top right)

Artists: Designed by M. Maier, D. Kehl, and G. Lantz; produced by The Group Y
Patron: Griffin Bacal Inc.
Location: 888 Seventh Avenue (at 56th Street)

Love Cow
(bottom right)

Artist: Romero Britto
Patron: CowParade New York 2000, Inc.
Location: 888 Seventh Avenue (at 56th Street)

Delft-Tiled Cow

Artist: Martie Holmer
Patron: PaineWebber
Incorporated
Location: 1285 Avenue
of the Americas
(at 51st Street)

Martie Holmer
Delft-Tiled Cow

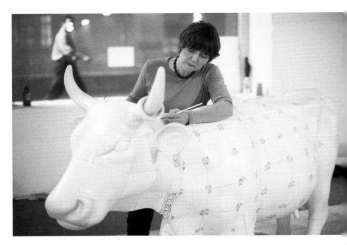

When Martie Holmer was a child, her family kept a china cow pitcher on the breakfast table. From that memory she came up with the idea of painting a cow to look like a delicate (yet humongous) porcelain figurine.

Although her research into the history of china cow pitchers proved to be a dead end, she did come across quite a lot of information about Delft tiles. "Before I knew it," Holmer said, "I had proposed painting a cow in the style of 17th-century Delft tiles, but using contemporary icons and vignettes of New York."

Like the Delft tiles of centuries ago, Martie Holmer's "tiles" tell a story or capture a scene or character that is distinctly New Yorkish. On the cow's tail you'll find an alligator—a reference to the most famous tale told about New York's sewers. Another tile features a portrait of Lord Cornbury in drag (the early-18th-century governor of New York liked to appear at formal functions dressed as his cousin, Queen Anne). There's even a tile of the artist herself in the pose of a milkmaid. Of course she's painting rather than milking her cow.

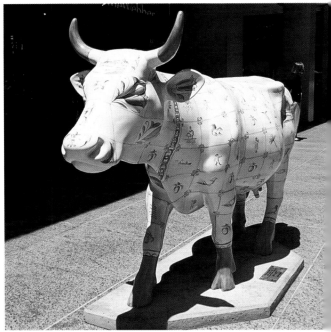

Picowsso
(top left)

Artists: Corinne Grondahl and Richard Meyer
Patron: CowParade New York 2000, Inc.
Location: 1350 Avenue of the Americas (at 55th Street)

Mooma
(top right)

Artist: R. Liza Levin, art teacher of PS 104, School District 27
Patron: BASF
Location: 888 Seventh Avenue (at 56th Street)

Yeeow! Moow York Moo Bugged Out!
(bottom)

Artist: Naomi Campbell
Patron: PaineWebber Incorporated
Location: 1251 Avenue of the Americas (at 49th Street)

Cows can hear lower and higher frequencies better than humans.

Liberty Cow

Artist: Burton Morris
Patron: CowParade New York 2000, Inc.
Location: 888 Seventh Avenue (at 56th Street)

Burton Morris *Liberty Cow*

The next time you're watching *Friends,* check out the paintings hanging on the wall in the Central Perk coffee house. They're the work of Burton Morris, one of the leaders of the New Pop Art movement.

Morris is one of the most visible artists working today. He's designed labels for Dubonnet, Perrier, and Pepsi-Cola; painted a 40-foot mural for the Houston Astrodome; was the official artist for World Cup '98; was named the official artist for the Winter Olympics 2002; and has accepted commissions from Anheuser Busch, American Express, Mitsubishi, Coca-Cola, Sony, AT&T, McDonalds, Coors, Hallmark, and Microsoft.

Morris's figures are lively and spontaneous, his colors bright and exotic. The artist says his style "has the feel of old woodcut engravings, but with a colorful twist."

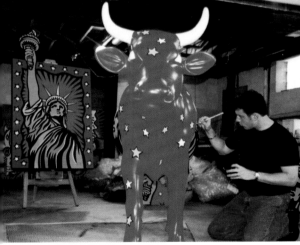

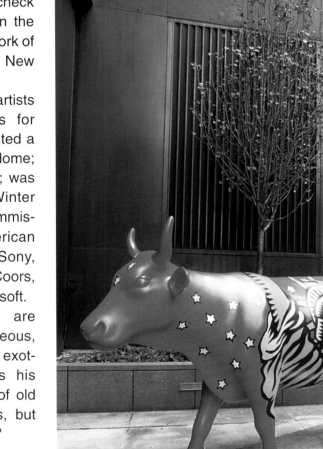

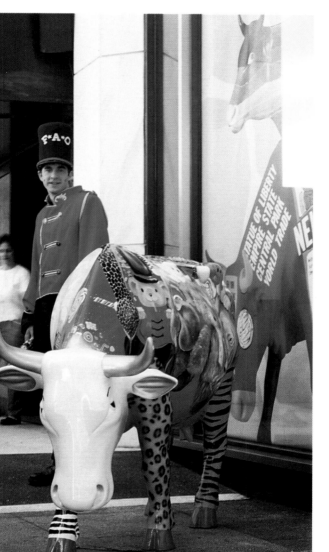

Betty Tompkins
Moo York Riv Vu

Unlike many of the artists who contributed to CowParade, cows are nothing new to Betty Tompkins. In fact, she has used cow images over 300 times in her 20-something-year career as an artist. Furthermore, for the past five years Tompkins has been painting three-dimensional forms, from bunnies to teddy bears to a concrete deer.

"Cows are easy to paint," Tompkins said. "Essentially, they are rectangles with things attached to them." The hard part for Tompkins was getting her cow into her studio. "We had a choice of cows," she said. "I picked the one that would fit in my elevator sitting on its tail."

Sweet Dreams
(left)

Artist: Candida Bayer
Patron: FAO Schwarz
Location: FAO Schwarz store (Fifth Avenue at 58th Street)

Moo York Riv Vu
(bottom right)

Artist: Betty Tompkins
Patron: CowParade New York 2000, Inc.
Location: 888 Seventh Avenue (at 56th Street)

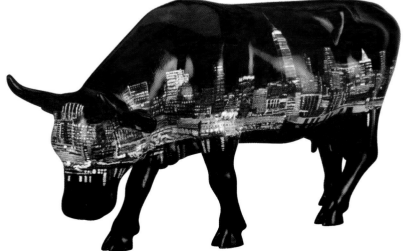

The Bronx Is Up, The Udder Is Down
(top left)

Artist: Keith Bendis
Patron: CowParade
New York 2000, Inc.
Location: 1251 Avenue
of the Americas
(at 49th Street)

Fresco
(right)

Artist: Crocket Effects
Patron: J. Crew
Location: 1251 Avenue
of the Americas
(at 49th Street)

Moo York Milly
(bottom left)

Artist: Julia Healy
Patron: NYC & Company
Location: 810 Seventh
Avenue (at 52nd Street)

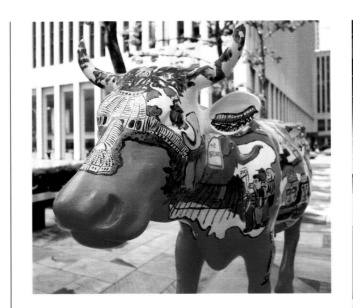

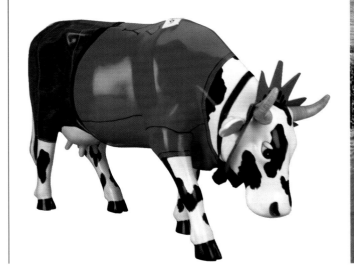

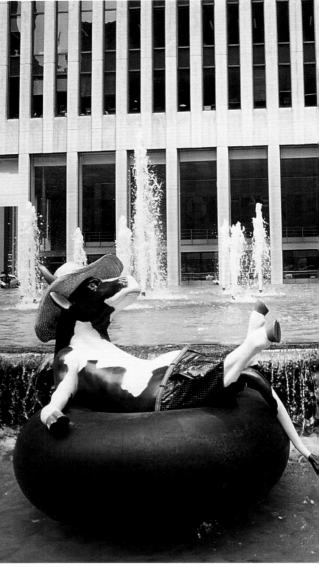

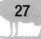

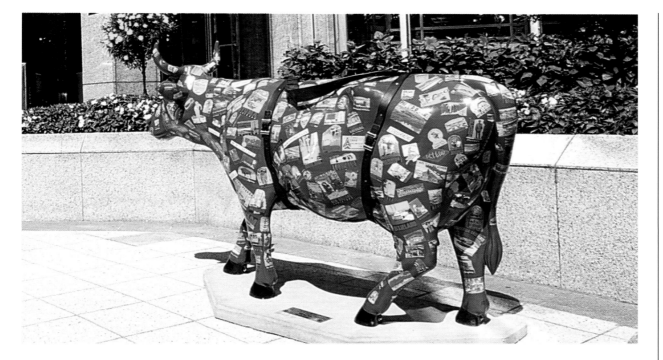

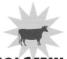 Thomas Kiley's *Traveling Luggage Cow:* Look closely at the luggage stickers and you'll notice that this well-traveled cow has avoided both Kansas City (renowned for its steakhouses) and Chicago (home of the notorious stockyards).

**HOLSTEIN
HALL OF
FAME**

Muranda Oscar Lucinda-ET of Marathon, Wisconsin, produced 67,914 pounds milk in one year.

The Early Show
(top left)

Artist: Suzanne Couture
Model Making
Patron: CBS
Location: 787 Fifth Avenue
(at 59th Street)

Daisy
in the Meadow
(top right)

Artist: Robert Kushner
Patron: Acquis Consulting
Group
Location: 1251 Avenue
of the Americas
(at 49th Street)

Picowso
(bottom)

Artist: Ron Howard
Patron: HBO
Location: 1211 Avenue
of the Americas
(at 48th Street)

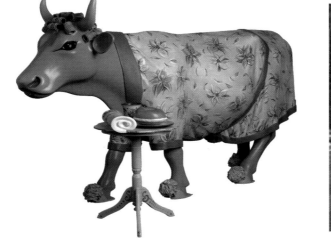

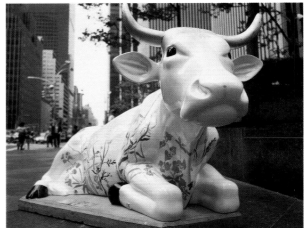

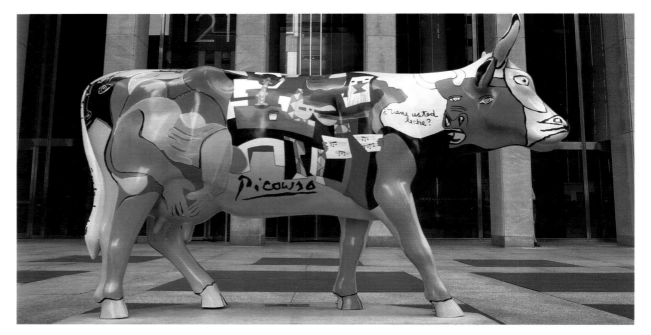

COW-QUISTADORS

The first cows—500 of them—arrived in what is now the United States in 1540 with the Spanish explorer Francisco Coronado.

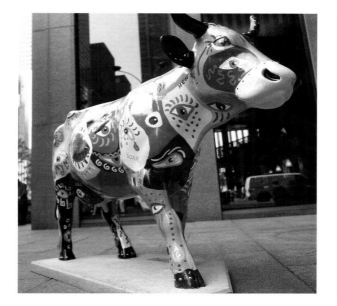

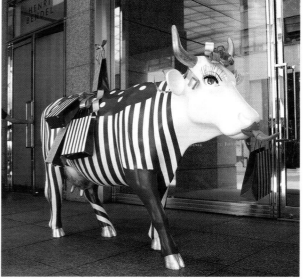

Ceci n'est pas une vache
(top)

Artist: Chet Kempczynski
Patron: CowParade
New York 2000, Inc.
Location: 1211 Avenue of the Americas
(at 48th Street)

Milk?
(bottom left)

Artist: Lara Knutson
Patron: CowParade
New York 2000, Inc.
Location: 1251 Avenue of the Americas
(at 49th Street)

Bendel's Bodacious Bovine
(bottom right)

Artist: The Henri Bendel Visual Team
Patron: Henri Bendel
Location: Henri Bendel Store, 712 Fifth Avenue
(at 56th Street)

Sunshine Cow
(top left)

Artist: Romero Britto
Patron: CowParade
New York 2000, Inc.
Location: 1251 Avenue
of the Americas
(at 49th Street)

Four-Alarm Cow
(top right)

Artist: Red Grooms
Patron: American Craft
Museum (made possible by
a gift from the Barbara and
Donald Tober Foundation)
Location: 40 West 53rd
Street

**Herds'n River
School**
(bottom)

Artist: David Dunlop
Patron: CowParade
New York 2000, Inc.
Location: 1211 Avenue
of the Americas
(at 48th Street)

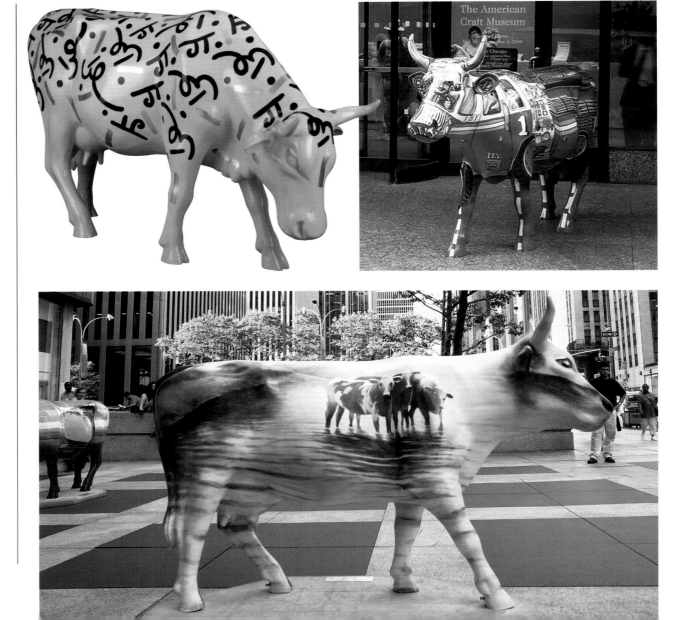

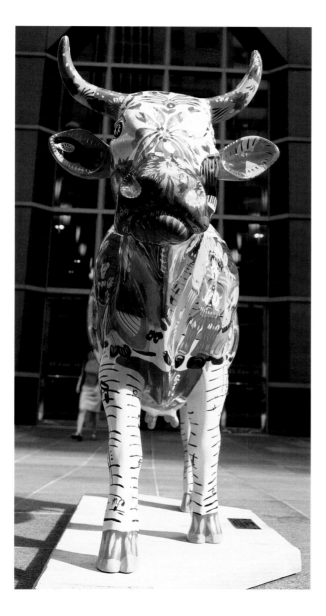

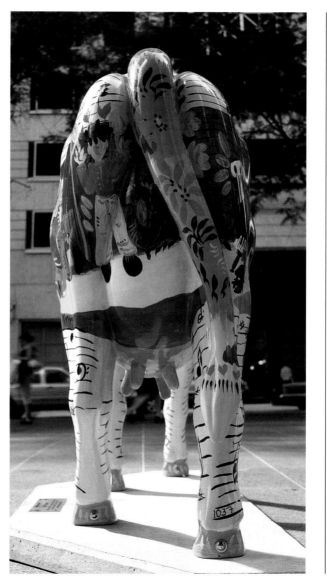

Save the Mooosic

Artist: Anna Yglesias,
Hei-Art
Patron: Equity Office
Properties Trust
Location: 65 East
55th Street

It takes 340 squirts to
fill a milk pail.

Victoria-Jungfrau Interlaken Cow
(top left)

Artist: Ted Scapa
Patron: Victoria-Jungfrau Grand Hotel & Spa
Location: Fifth Avenue at 55th Street

The Page
(right)

Artist: Candida Bayer
Patron: The Peninsula New York, Official Host Hotel of CowParade New York 2000
Location: The Peninsula, 700 Fifth Avenue (at 55th Street)

Ears to You New York
(bottom left)

Artists: Ed Rodriguez and Chris Schnabel
Patron: The Disney Store
Location: 711 Fifth Avenue (at 52nd Street)

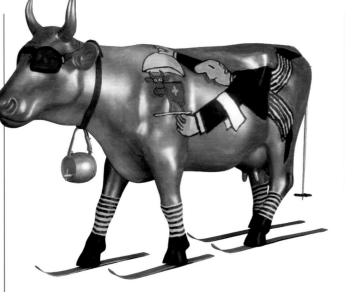

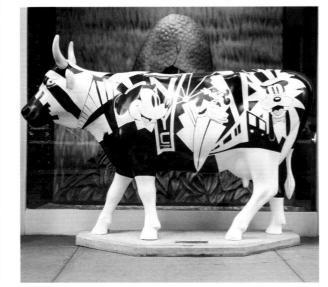

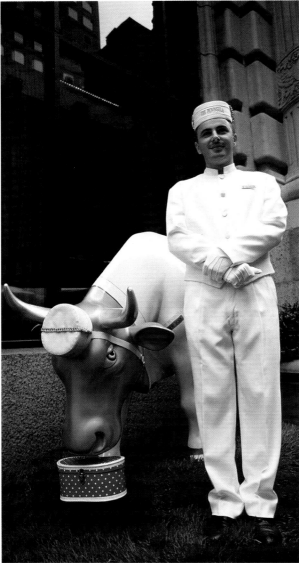

Paley Park

Few people who visit Paley Park, a narrow slip of land on East 53rd Street that features a wall of falling water, realize that it is the site of the legendary Stork Club.

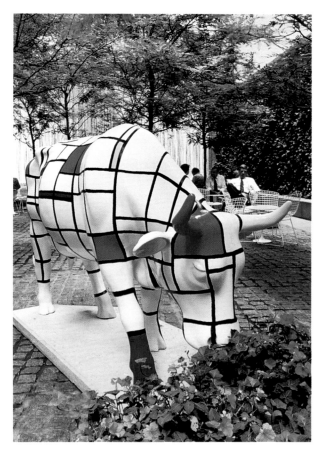

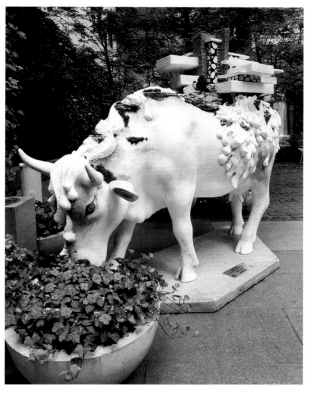

Moondrian
(left)

Artist: Jon Eastman
Patron: CowParade
New York 2000, Inc.
Location: Paley Park,
3 East 53rd Street

Falling Udder
(right and detail, bottom))

Artist: Linda Eisenberg
Patron: CowParade
New York 2000, Inc.
Location: Paley Park,
3 East 53rd Street

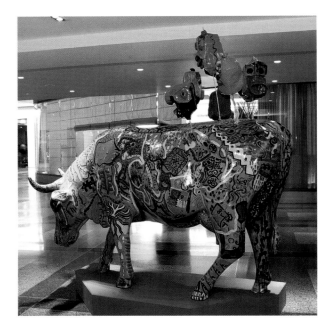

Rockefeller Center

If any spot in New York City can be identified as "ground zero," it has to be Rockefeller Center. With its benches and sculptures, its fountains and banks of flowers, its sunken plaza in summer, its skating rink in winter, and its massive Christmas tree in December, this is one of Midtown's friendliest spots.

As home to RCA and NBC, Rockefeller Center has made broadcast history time and again. The first radio broadcasts of the NBC Symphony Orchestra, conducted by Arturo Toscanini, originated from here on Christmas Day, 1937. The studios in the RCA Building were home to Milton Berle's Texaco Star Theater, which began airing in 1948 and became the first TV hit. The RCA Building was also the site of TV's notorious *Twenty-One* quiz show scandal. (The whole sordid affair was dramatized in the movie *Quiz Show,* starring Ralph Fiennes as Charles Van Doren, the contestant-who-couldn't-lose.)

Jewel
(bottom left)

Artist: Steven Lagos
Patron: Lagos
Location: Rockefeller Center (concourse level)

Magical Cow of the Universe
(top right)

Artist: Janet Slom
Patron: CowParade New York 2000, Inc.
Location: Rockefeller Center (concourse level)

.cow
(bottom right)

Artist: Robert Adams
Patron: Banana Republic
Location: Fifth Avenue and 51st Street

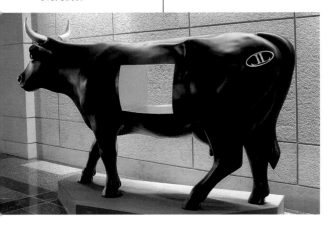

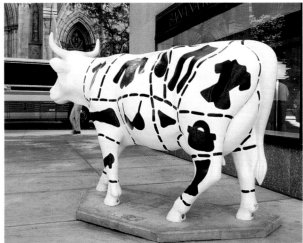

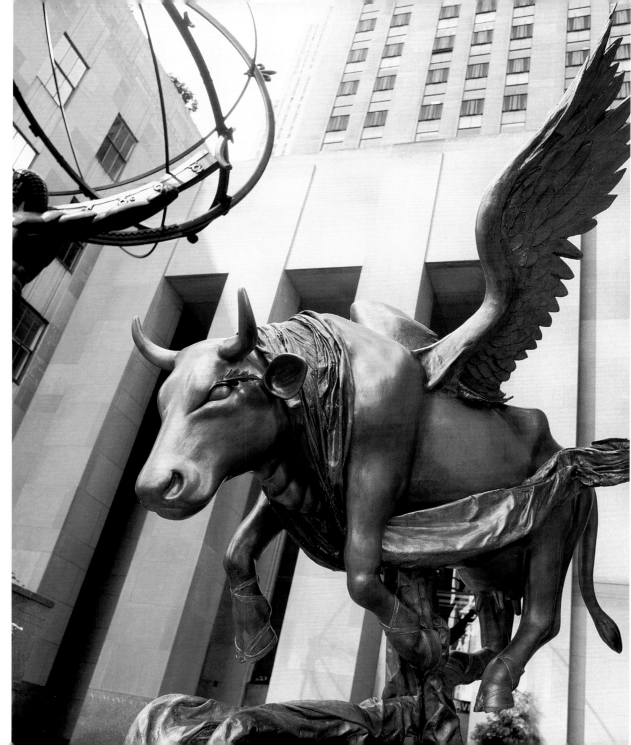

Holy Cow

Artists: Vincent Longo
with Izquierdo Studios
and Vincenzo Nasti
Patron: Sephora
Location: Fifth Avenue
and 51st Street

DID YOU KNOW?

A mature Holstein
cow weighs about
1,500 pounds and
stands 58 inches tall
at the shoulder.

Daisy

Artist: James Rizzi
Patron: CowParade
New York 2000, Inc.
Location: Bennington
Gallery, Fifth Avenue at
46th Street

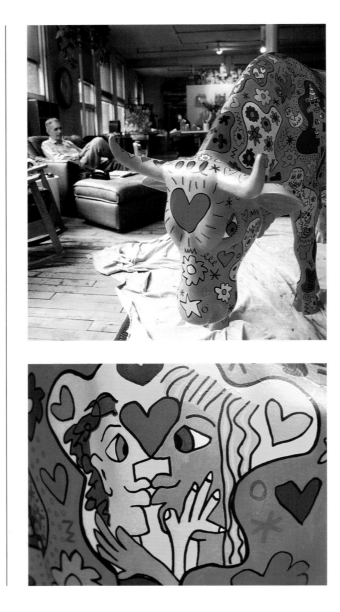

James Rizzi

James Rizzi is one of the best-loved and best-known New York artists. SoHo galleries exhibit his original work while souvenir shops around the city sell poster and post card reproductions of his eccentric, exuberant street scenes.

Urban themes are in James Rizzi's blood. He was born in Brooklyn, so he knows first-hand the edgy appeal of New York.

As a student at the University of Florida (Gainesville), Rizzi experimented with painting, printmaking, and sculpture. In time he was able to combine all three techniques in the bold, colorful, animated 3-dimensional constructions that have become his trademark.

Rizzi made his debut at the Brooklyn Museum in 1974. Since then he has been honored with one-man shows throughout the United States, Europe, and Asia.

And Rizzi has scored some attention-grabbing commissions. He designed a Boeing 747 aircraft for Lufthansa Airlines in 1996; he created a series of paintings commemorating the opening ceremonies of the 1996 Olympic Games in Atlanta; and he was the official artist of the Montreux Jazz Festival in 1997.

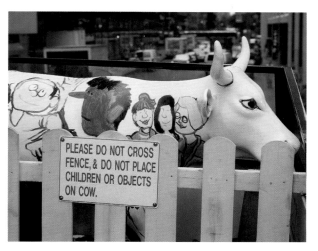

PLEASE DO NOT CROSS FENCE, & DO NOT PLACE CHILDREN OR OBJECTS ON COW.

Graylene
(top left and right)

Artist: Jessie Gifford
Patron: Gray Line
New York Tours
Location: on a Gray Line bus

Fish Cow
(bottom left)

Artist: Rea Nurmi
Patron: Bahamas
Ministry of Tourism
Location: Rockefeller
Center (concourse level)

Miss Swiss
(bottom right)

Artist: Garance
Patron: Hanro of
Switzerland
Location: Rockefeller
Center (concourse level)

Daisy's Dream

Artist: Randy Gilman
Patron: CowParade
New York 2000, Inc.
Location: 230 Park Avenue
(at 46th Street)

Randy Gilman
Daisy's Dream

Randy Gilman describes himself as someone who has "a good background in taking the watch apart and seeing how things tick." He's found lots of interesting outlets for his design and construction talents. He built a 36-foot footbridge for a client in the Berkshires. He collaborated on a model of a da Vinci flying machine showcased in the Smithsonian's Air and Space Museum. He even helped build the clear plastic face masks Bruce Willis wore in the movie *12 Monkeys*. So it stands to reason that if anybody was going to get a fiberglass cow to leap into the air and catch a frisbee, it would be Gilman.

He started by cutting his cow into 50 pieces. Then he made a steel tubular armature and built Daisy around it. The base of swirling grass dotted with daisies is made of steel, plywood, and fiberglass. And yep, that's a real frisbee 10-foot-tall Daisy is catching.

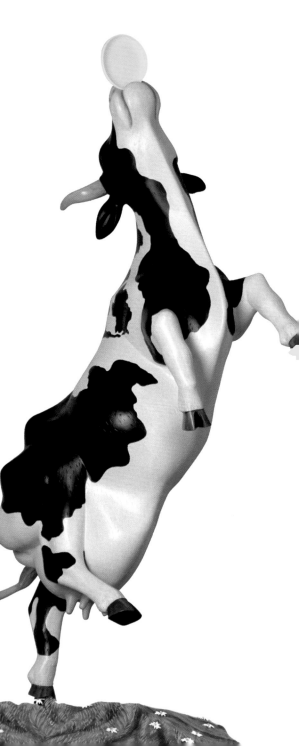

Maxine
(top)

Artist: Peter Max
Patron: DNJ–MOJ
Location: Park Avenue
Mall at 57th Street

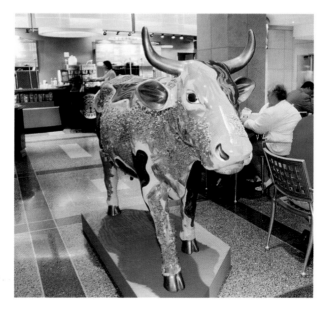

The Green Bean Moo-Cha Cow
(bottom left)

Artist: Aisha Richards
Patron: Starbucks
Coffee Company
Location: Rockefeller
Center (concourse level)

Uphill Crimson, A Rare Belted Galloway
(bottom right)

Artist: E. Connolly
Patron: Uphill Farm, Clinton
Corners, New York 12514
Location: Rockefeller
Center (concourse level)

Hot Rod
(left)

Artist: Patrick Thorne
Patron: I-20 Gallery,
New York
Location: Park Avenue
Mall at 54th Street

**Cosmic Cow—
the Milky Way
to Broadway**
(top right)

Artist: Arthur Guerra
Patron: DNJ-MOJ
Location: Park Avenue Mall
at 51st Street

**Technicolor
Dreamcow**
(bottom right)

Artist: Orly Cogan
Patron: I-20 Gallery,
New York
Location: Park Avenue
Mall at 55th Street

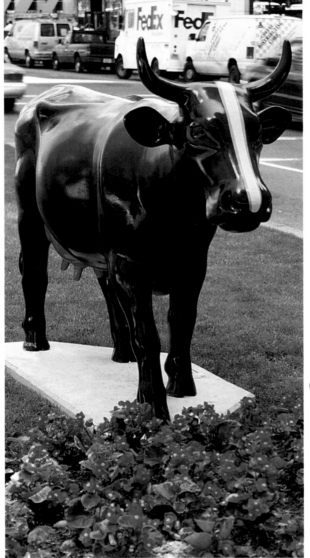

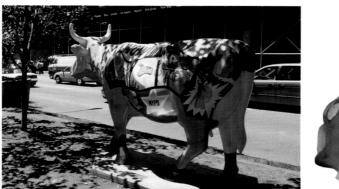

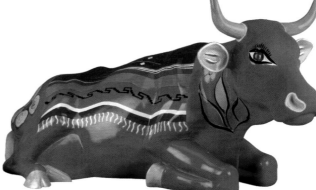

How Ya Gonna Keep 'Em Down on the Farm?
(top left)

Artist: Arthur Guerra
Patron: DNJ-MOJ
Location: Park Avenue Mall at 50th Street

Sleepy-Time Cow
(top right)

Artist: Homer Guerra
Patron: DNJ-MOJ
Location: Park Avenue Mall at 53rd Street

Cow-To Book
(bottom)

Artist: Zora
Patron: Borders Books & Music
Location: Borders store at 461 Park Avenue (at 57th Street)

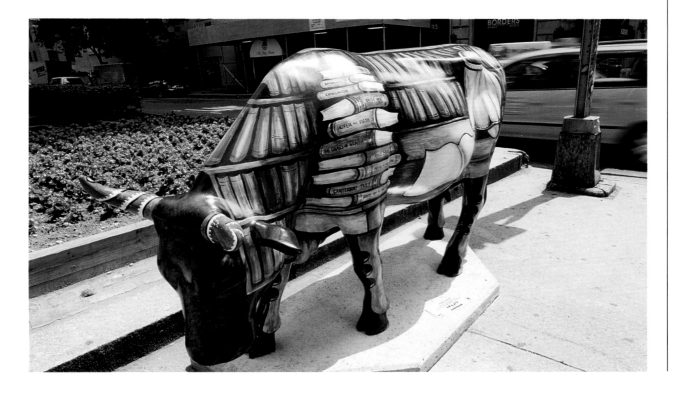

Precision Cow
(top left)

Artist: Nolde Banziger
Patron: Vontobel USA Inc.
Location: 909 Third Avenue
(at 55th Street)

The Mixtec Cow
(top right)

Artist: Brenda Bradley,
art teacher of IS 139,
School District 7
Patron: BASF
Location: 909 Third
Avenue (at 55th Street)

Mooters Girl
(bottom left)

Artist: Doug Wright
Patron: Hooters
Location: 211 West
56th Street Plaza

Bloomie
(bottom right)

Artist: Laurie Douglas
Patron: Bloomingdale's
Location: Bloomingdale's
(Third Avenue between
59th and 60th Streets)

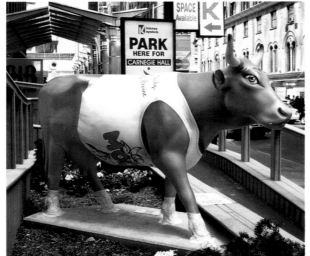

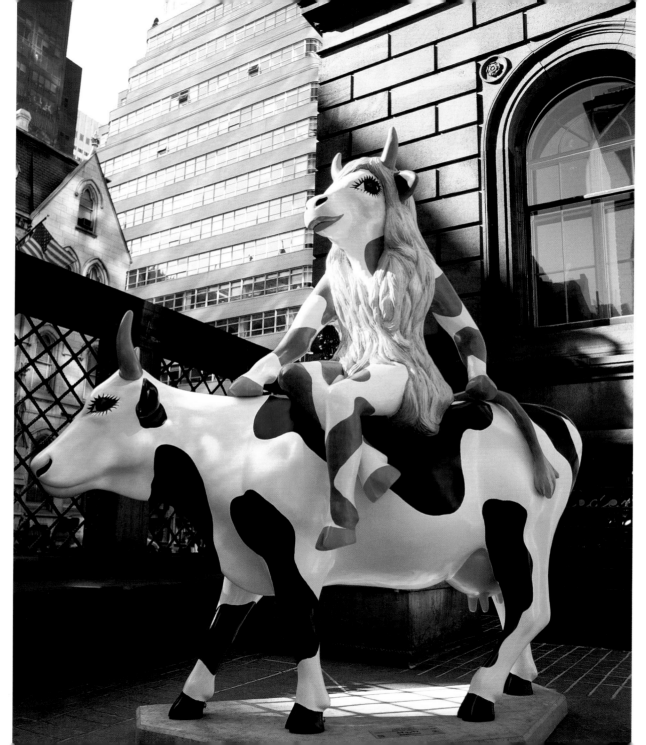

A Holstein's spots are like snowflakes: no two Holsteins have exactly the same pattern.

Lady Cowdiva

Artist: Tim Gaydos
Patron: The New York Palace/Le Cirque 2000
Location: 455 Madison Avenue (at 51st Street)

Cow of Many Colors
(top left)

Artist: Marjorie Blackwell
Patron: CowParade
New York 2000, Inc.
Location: 909 Third Avenue
(at 55th Street)

Cow of Many Cows
(top right)

Artist: Matthew Geller
Patron: 345 Park Avenue LP
Location: 345 Park Avenue
(at 52nd Street)

Bridge Building Cow
(bottom left)

Artist: Nolde Banziger
Patron: Vontobel USA Inc.
Location: 909 Third Avenue
(at 55th Street)

ZOW!
(bottom right)

Artist: Lewandowski-Lois
Patron: DNJ-MOJ
Location: Park Avenue Mall
at 57th Street

The Forties

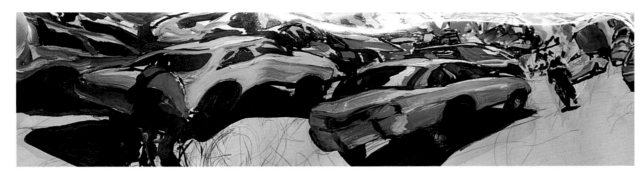

Tom Christopher
Times Square Cow

Tom Christopher schlepped his cow to Times Square and spent a day painting at the foot of Father Duffy's statue. So what type of reaction did he get? "Surprisingly little," Christopher said. "New Yorkers aren't fazed by a guy painting a cow in Times Square."

Christopher's specialty is painting busy scenes of New York City street life (you can see a 250-foot mural he painted at Roseland, a club on 52nd Street). His cow has the same energy as his canvases. Cabs scream up either side of the cow, and crowding the sidewalks are grifters, con men, theatrical agents, and bike messengers—"all the people you usually see in Times Square."

Times Square Cow
(bottom right and detail, top)

Artist: Tom Christopher
Patron: HIP Health Plan of New York
Location: Penn Station

Taxi Cow
(top)

Artist: Jacqueline Fogel
Patron: CowParade
New York 2000, Inc.
Location: Port Authority
Bus Terminal

Moo Jersey Diner
(bottom)

Artist: Brooklyn Model
Works
Patron: DVC Group,
Morristown, New Jersey
Location: Port Authority
Bus Terminal

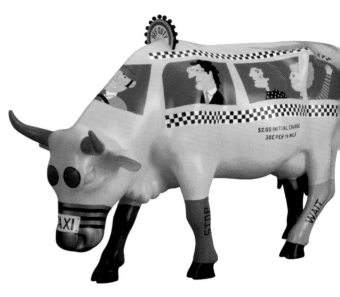

Port Authority

In an average year, 56 million travelers and commuters pass through the Port Authority Bus Terminal. Situated on Eighth Avenue between West 40th and 42nd Streets, the Port Authority is surrounded by one of the city's more colorful neighborhoods. Regular commuters who pass through the Port every day have seen New York at its weirdest, so they probably won't even notice the cows.

All those millions of commuters have something on their mind, and it isn't livestock: they're trying to get a cab. For many New Yorkers, hailing a cab is an art form. And New Yorkers have been practicing their art for nearly a century—since 1907, when the slow-moving battery-powered cabs were replaced by faster gas-powered ones. The new gasoline taxis also came equipped with a taximeter, an innovative gadget that put an end to fare gouging.

Taxis are what New Yorkers would be if they had an internal combustion engine: aggressive, confrontational, occasionally reckless. It's been like that from the beginning. In 1907, 5,000 cabbies went out on strike demanding higher wages and the right to unionize. In 1913, the city took its first shot

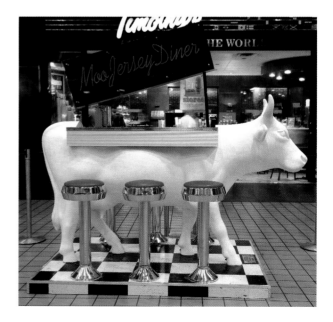

at price regulation, setting the fare at 50 cents a mile. In 1923, the police department claimed the right to license cabs, arguing that taxis were being used as getaway cars for holdup artists and bootleggers. In 1932, it was revealed that the Checker Cab Company had paid heavy bribes to Mayor James J. Walker.

Cabbies went out on strike again in 1934, 1939, 1949, 1956, and 1965. One of their favorite, surefire methods of getting the public's attention was to block traffic. This technique was repeated in 1993 when, to protest a rash of armed robberies and murders, cabbies drove in tight formation and very slowly down New York's major avenues.

COW LORE

If a cow lies down and does not graze, a storm is on its way.

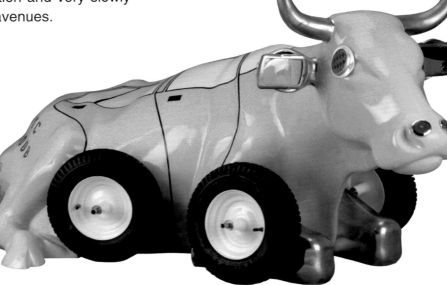

Checkers the Taxi Cow
(top)

Artist: Olivia Borges Veras, of PS/IS 217, School District 2
Patron: BASF
Location: Port Authority Bus Terminal

Cabbie Cow
(bottom)

Artist: Cynthia Chan
Patron: Emigrant Savings Bank
Location: Port Authority Bus Terminal

Cow-Cam

Artist: Jack McConnell
Patron: CowParade
New York 2000, Inc.
Location: 1114 Avenue
of the Americas
(at 43rd Street)

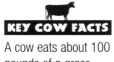

KEY COW FACTS

A cow eats about 100
pounds of a grass
each day.

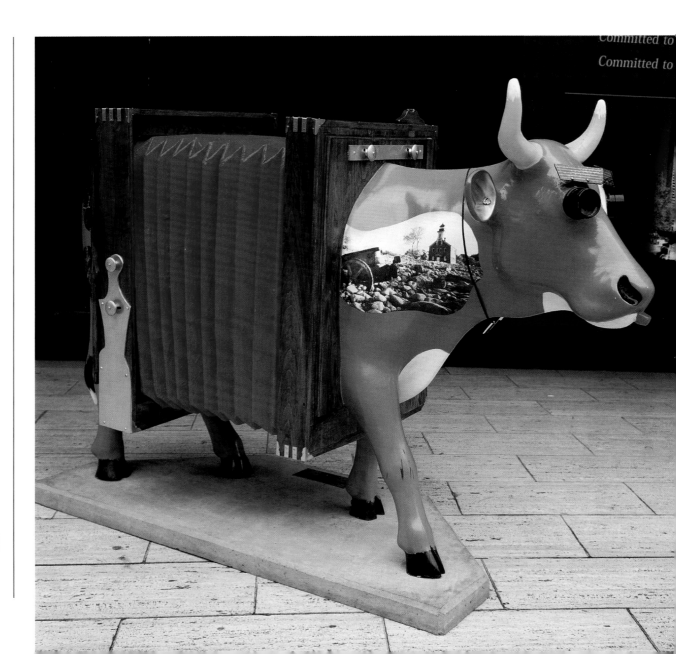

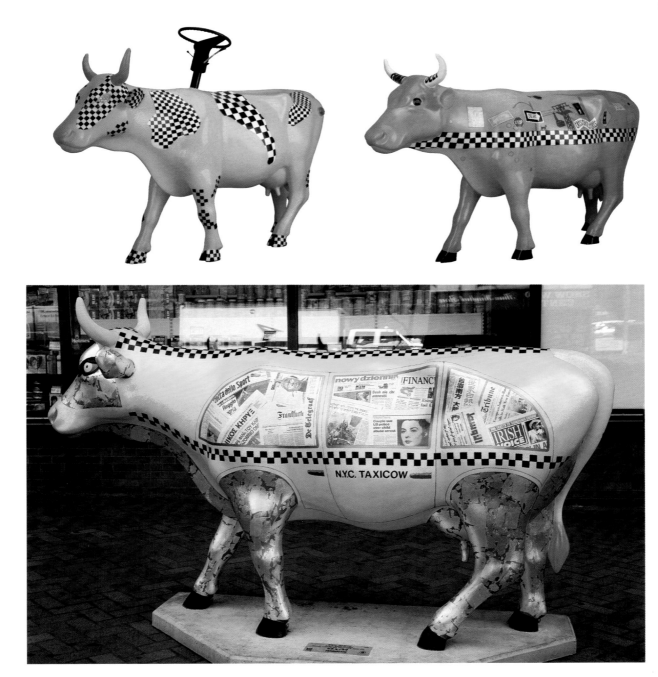

Checker Cab Cow
(top left)

Artist: Ursula Clark
Patron: HBO
Location: Port Authority
Bus Terminal

On the Moo
(top right)

Artists: Terry Donsen Feder
and Elizabeth Feder
Patron: CowParade
New York 2000, Inc.
Location: Port Authority
Bus Terminal

Super TaxiCow
(bottom)

Artist: Sylvie Mueller
Patron: CowParade
New York 2000, Inc.
Location: Port Authority
Bus Terminal

La Moochachka
(top left)

Artist: Sandra Golbert
Patron: Fashion Center BID
Location: 1411 Broadway
(at 41st Street)

A Walk
in the Pasture
(top right)

Artist: Ron Burns,
HSUS Artist in Residence
Patron: The Humane
Society of the United States
Location: 1221 Avenue
of the Americas
(at 49th Street)

Big Apple Cir-Cow
(bottom left)

Artist: Catherine Krebs
Patron: CowParade
New York 2000, Inc.
Location: 1411 Broadway
(at 41st Street)

The Milky Way
(bottom right)

Artists: Leon and
Elaine Smith
Patron: TrizecHahn Office
Properties, Inc.
Location: 1411 Broadway
(at 41st Street)

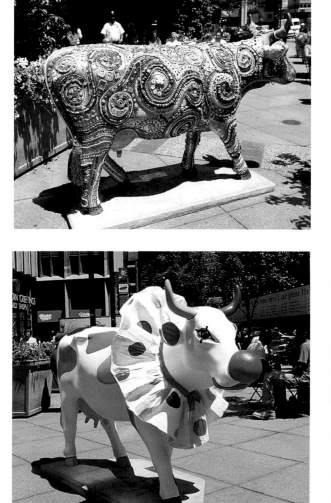

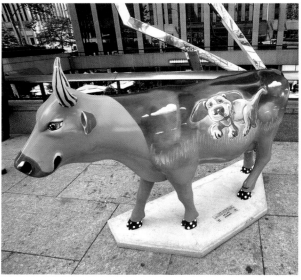

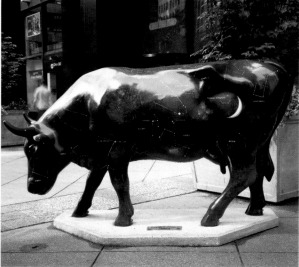

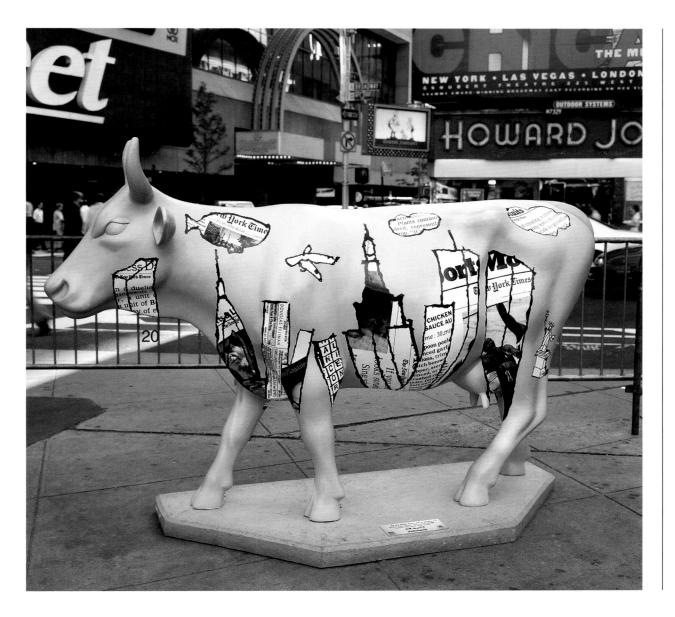

All the Moos That's Fit to Print

Artists: Dan Baxter and Bruce Hanke
Patron: The New York Times
Location: Duffy Square (Broadway at 46th Street)

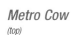

Metro Cow
(top)

Artist: James Haggerty III,
teacher, IS 383,
School District 32
Patron: BASF
Location: Grand Central
Terminal

Diversity of People
(bottom)

Artist: Rumiko Tsuda
Patron: CowParade
New York 2000, Inc.
Location: 1221 Avenue
of the Americas
(at 49th Street)

I Cow
(opposite page, top)

Artist: Nicoletta Barolini
Patron: Del Frisco's Double
Eagle Steakhouse
Location: 1221 Avenue
of the Americas
(at 49th Street)

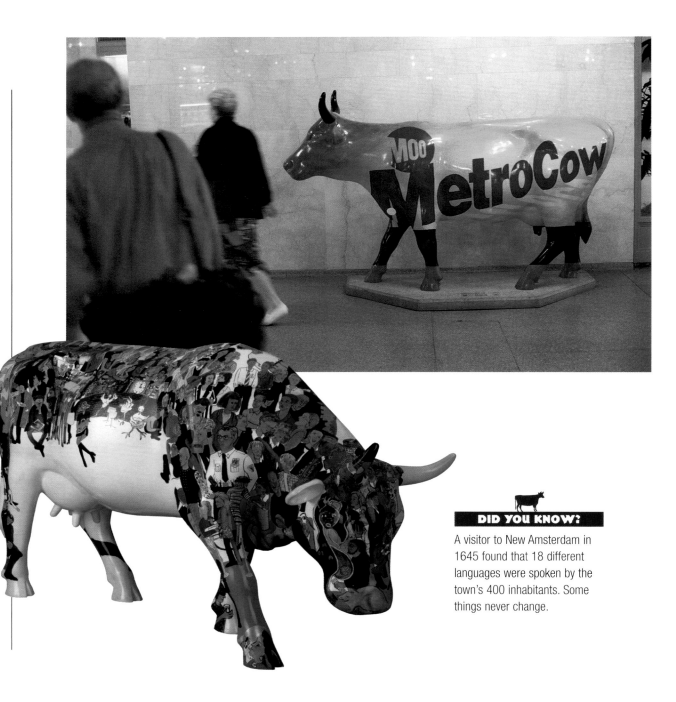

DID YOU KNOW?

A visitor to New Amsterdam in 1645 found that 18 different languages were spoken by the town's 400 inhabitants. Some things never change.

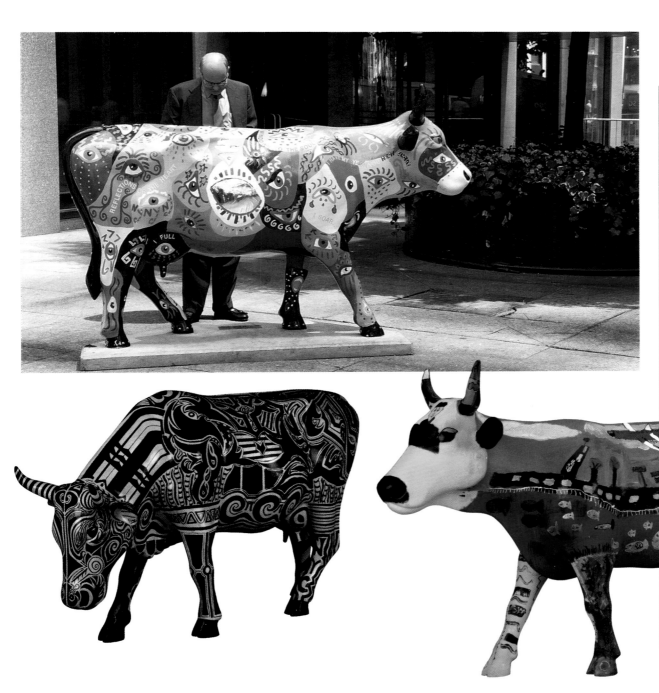

Tattooed Bovine
(bottom left)

Artist: Georges P.
Le Chevallier
Patron: Arkansas Cancer
Research Center
Location: 1411 Broadway
(at 41st Street)

Transportation
(bottom right)

Artists: Students from PS
100, Bronx School District 8,
including Christopher
Valentin, Jayna Smith, Toure
Barnes, Amanda Granados,
Cairon Charles, Shelivia
Ocasio, and Rachel Kelly
Patron: BASF
Location: 1221 Avenue of
the Americas (at 49th Street)

Housing
(top left)

Artists: Students from PS 100, Bronx School District 8, including Anthony McKenzie, Bianca Bell, Angeleah Isidore, Trevate McCall, Ryan Torres, Delnisha Baker, and Megan Gilmore
Patron: BASF
Location: 1221 Avenue of the Americas (at 49th Street)

Combination of All Themes
(bottom left)

Artists: Students from PS 100, Bronx School District 8, including Felix Jusino, Cynia Barnwell, Alisha Bronne, Natasha Stanislas, Erica Rodriquez, Raven Robinson, and Talya Baker
Patron: BASF
Location: 1221 Avenue of the Americas (at 49th Street)

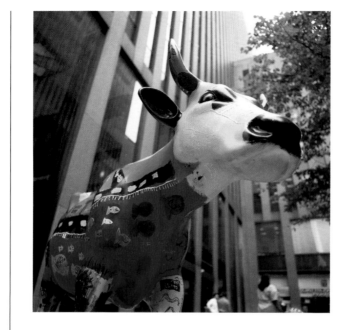

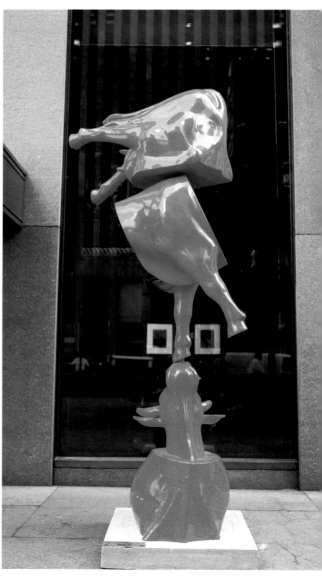

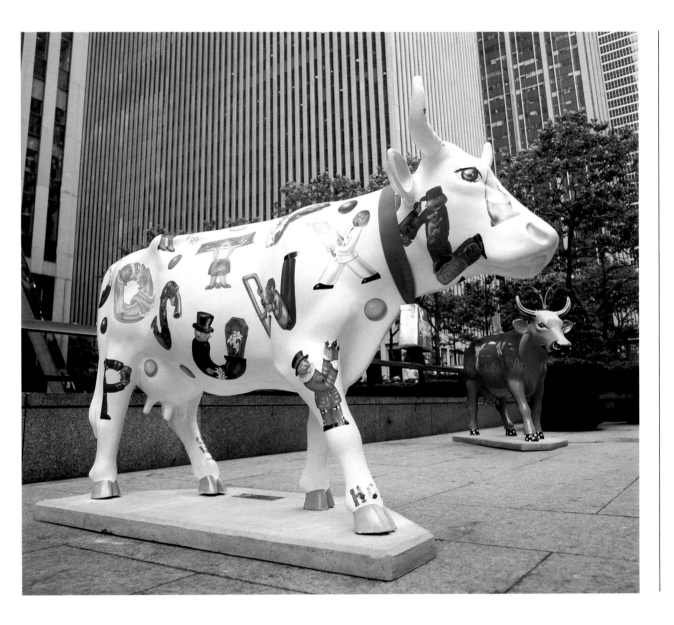

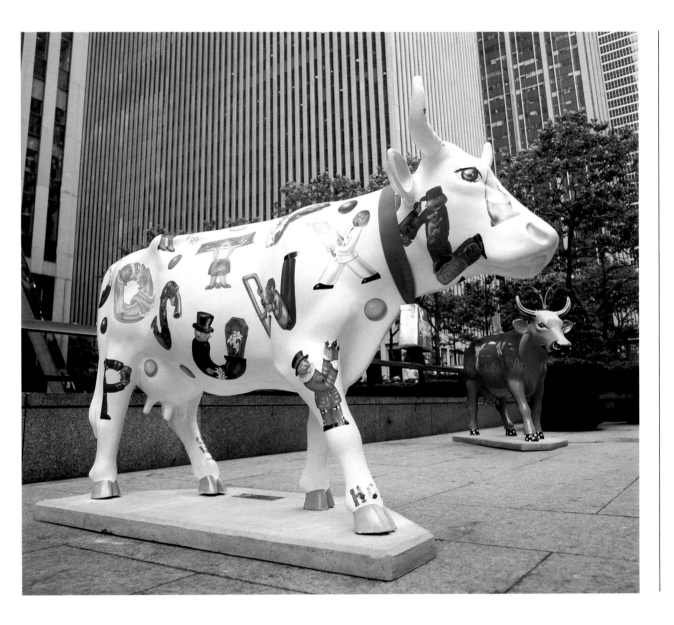

Edu-cow-tion

Artist: Donna Kern
Patron: McGraw-Hill School Division
Location: 1221 Avenue of the Americas (at 49th Street)

MooMA
(opposite page, right)

Artist: Ellen Hanauer
Patron: Del Frisco's Double Eagle Steakhouse
Location: 1221 Avenue of the Americas (at 49th Street)

Broadway Baby
Artist: Candida Bayer
Patron: Hilton New York
Location: Bryant Park

Bryant Park

Nestled behind the New York Public Library, Bryant Park is a welcome patch of green in the concrete heart of Midtown. It's a favorite lunchtime destination for office workers in the neighborhood who collect here after foraging for food at local delis and take-out restaurants.

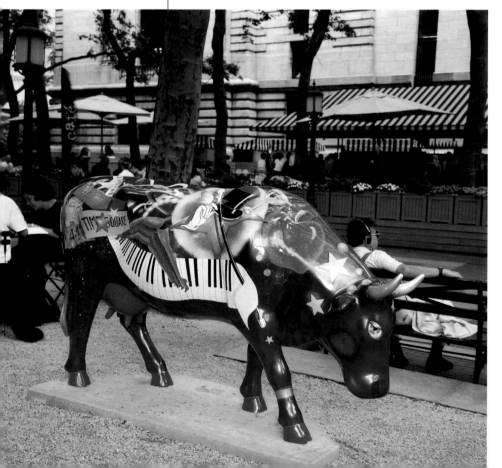

The park's beginnings were anything but idyllic. In the early 1820s, convict labor cleared the site so it could be used as a potter's field, a burial ground for the anonymous and the indigent. By 1847, the cemetery had been reclaimed as a public park known as Reservoir Square because it backed up against the massive stone wall of the Croton Reservoir (the scene of the climatic conclusion to Caleb Carr's historical thriller, *The Alienist*).

During the Civil War the park was a camp for Union soldiers. In 1884, it was renamed Bryant Park in honor of William Cullen Bryant, poet, newspaperman, and advocate of public green spaces. In 1970, the park was the site of a celebration of the 50th anniversary of the passage of the Nineteenth Amendment, which gave American women the right to vote. Gloria Steinem, Kate Millet, and Betty Friedan addressed a crowd of 10,000 women.

During the 1970s and 1980s, the park degenerated into an outdoor market for drug dealers. In the early 1990s, the park was closed for extensive renovations, which included installing underground storage for the Library, easier public access, and new landscaping. Today Bryant Park is Midtown's most attractive oasis.

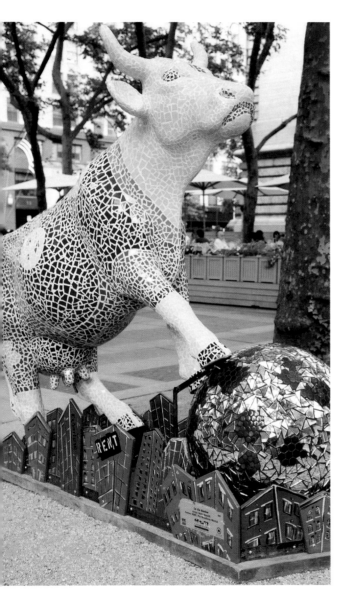

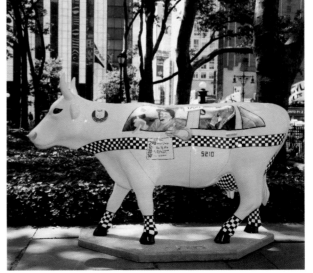

La Vie Bovine
(left)

Artist: Matt Maraffi
Patron: RENT: The
Broadway Musical
Location: Bryant Park

NAM Cow
(top right)

Artist: Derek Stenbourg
Patron: National Artists
Management Company
Location: Bryant Park

Taxi Cow
(bottom right)

Artists: T. Schwartz, A.
Erhardt, and I. Richards
Patron: Young & Rubicam
New York
Location: Bryant Park

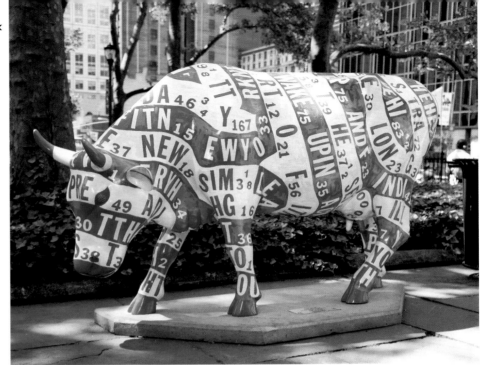

Cow Ticker
(top and detail below)

Artist: Mike Rollins
Patron: Reuters America, Inc.
Location: Bryant Park

A la "Moo"tisse
(bottom left)

Artists: Aimée Esposito and Mary Louise Gladstone, art teachers of PS 170, School District 20
Patron: BASF
Location: Bryant Park

Streetsmart Cow
(bottom right)

Artist: Allison Beispel
Patron: Emigrant Savings Bank
Location: Bryant Park

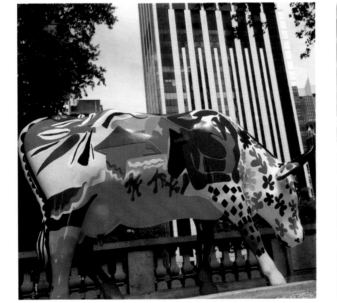

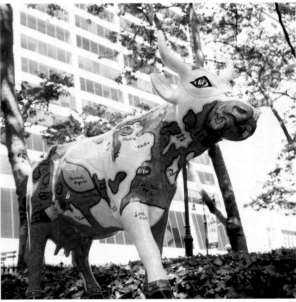

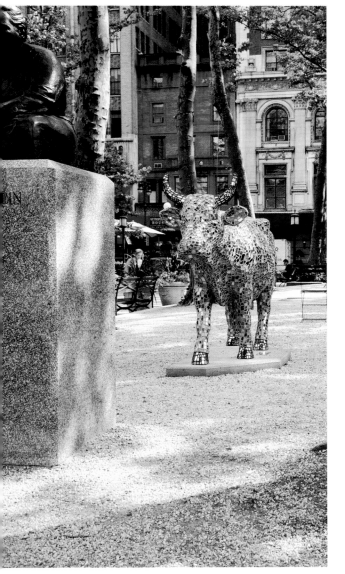

Jeffrey Conroy
Cowleidoscope

Jeffrey Conroy is a Chicago artist whose contribution to the Chicago CowParade, *Mirroriam*, was voted Most Popular Cow in Chicago and raised $65,500 at the CowParade charity auction.

Glass mosaic is one of Conroy's specialties, and he's no stranger to decorating sculpture. Recently he covered a life-size figure of a Thoroughbred horse with glass.

For New York's CowParade, Conroy covered his cow with an iridescent glass mosaic. "It took over 10,000 pieces of glass," Conroy said, "and 200 hours to complete." And Conroy worked alone.

Cowleidoscope

Artist: Jeffrey Conroy
Patron: Stefan Hunter
Location: Bryant Park

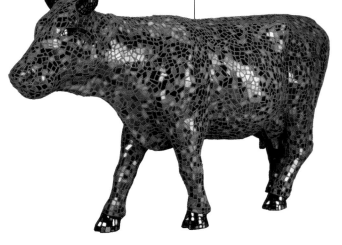

Edwina Sandys
Moobile Library **and** *Cow Hands*

DID YOU KNOW?

The Holstein gestation period is nine months, give or take a week.

Moobile Library

Artist: Edwina Sandys
Patron: New York Public Library
Location: New York Public Library, Fifth Avenue at 42nd Street

"It's not a dead end, this cow, for me," said Edwina Sandys. Inspired by the two cows she created for CowParade, the sculptor is planning a series of three-dimensional works that are spinoffs of her *Moobile Library*.

Moobile Library is covered with bookshelves and the shelves are crammed with books. Sandys invited the authors whose books appear on the cow to stop by the New York Public Library and autograph the cow. She plans to continue the literary theme in her sculptural series with a Literary Horse, a Literary Dog, a Literary Woman, and a Literary Man.

The inspiration for Sandys' other cow, *Cow Hands*, (page 16) is distinctly different. Across the bright blue body of the cow, where one would expect to see spots, Sandys painted large white female hands with long red fingernails. The hands motif is an allusion to a collection of photographs of hands owned by the cow's sponsor, Henry Buhl. "It also is a reminder of the helping hands of the SoHo Partnership," Sandys said, referring to an organization that helps homeless men and women reenter the work force.

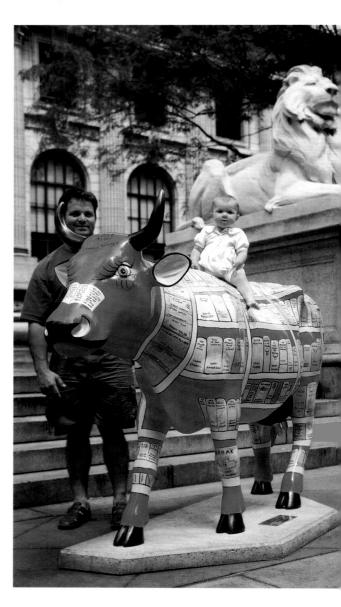

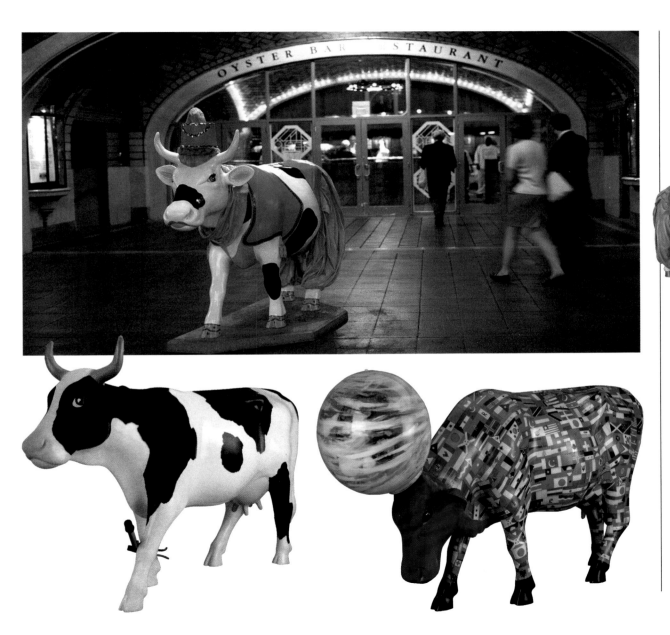

Grade A HomoJEANNIEzed Milk
(top)

Artist: Ann Yzuel
Patron: TV Land
Location: Grand Central Terminal

No Radio
(bottom left)

Artists: Bob Lapides, Angela Moore, Chris Perone
Patron: Foote, Cone & Belding
Location: 150 East 42nd Street

A Cow for the United Nations
(bottom right)

Artist: German Perez
Patron: City Guide Magazine
Location: 866 UN Plaza (First Avenue and 44th Street

Mootress the Pasturepedic Cow
(top left)

Artist: Stephanie Krause and Robert Christie
Patron: The Crowne Plaza Hotel at the United Nations
Location: The Crowne Plaza Hotel, 304 East 42nd Street

Pharmooceutical
(top right)

Artists: Caryn Goldberg with Alice Falkowitz
Patron: Pfizer
Location: 235 East 42nd Street

Cow-ch Potato
(bottom)

Artist: Linda Eisenberg
Patron: CowParade New York 2000, Inc.
Location: Grand Central Terminal

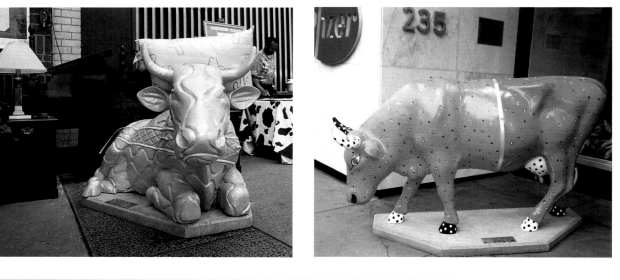

My Parents' Cow

Artist: Richard Haas
Patron: CowParade
New York 2000, Inc.
Location: Grand Central
Terminal

Richard Haas
My Parents' Cow

Cows have a very special meaning for painter Richard Haas. His father was a butcher and his mother was one of the first people in America known to have died of "mad cow disease." Haas's cow is dedicated to their memory.

Flags
(top)

Artists: M. Polanco,
L. Polanco, and A. Mateo
with K. Anglim, art teacher
of JHS 45, School District 4
Patron: BASF
Location: Dag
Hammarskjöld Plaza
(at the United Nations)

Newspaper Cow
(bottom left)

Artist: Katerina Boiko, of
John Dewey High School,
Brooklyn
Patron: BASF
Location: 866 UN Plaza
(First Avenue and 44th
Street)

Hope Blossom
(bottom right)

Artist: Rene Lynch
Patron: Swiss Re Capital
Partners
Location: 230 Park Avenue
(at 46th Street)

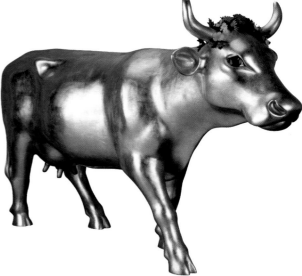

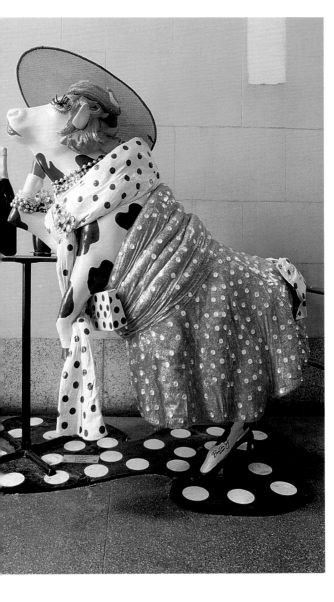

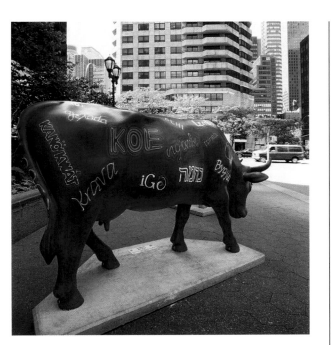

**Looking for
Mr. Good-Cow**
(left)

Artist: Barton G. ™
Patron: BGW Design
Limited, Inc.
Location: 230 Park Avenue
(at 46th Street)

Polyglot Cow
(top right)

Artists: Gayle Asch, art
teacher, with Lola Planells
of Bronx High School of
Science, the Bronx
Patron: BASF
Location: Dag
Hammarskjöld Plaza
(at the United Nations)

Big Apple Cow
(bottom right)

Artist: Thomas Naegele
Patron: Bank of America
Location: 335 Madison
Avenue (at 42nd Street)

HOLSTEIN HALL OF FAME

Bell-Jr Rosabel-ET of Calhan, Colorado, produced 60,380 pounds milk in one year.

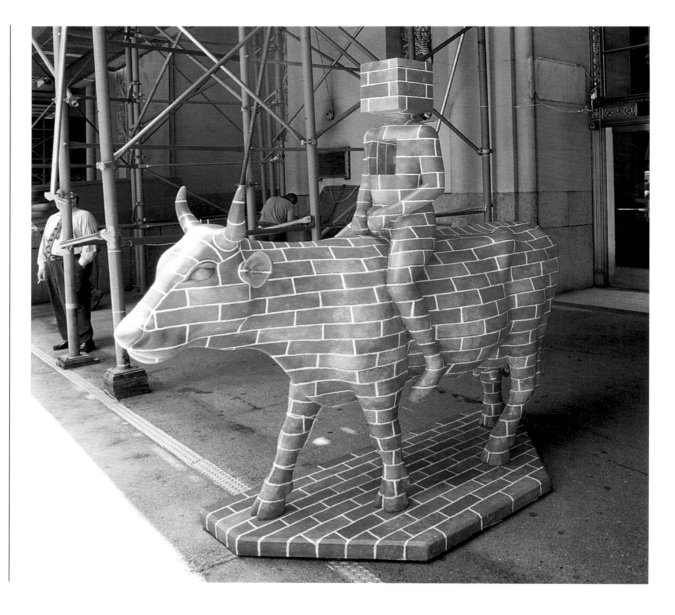

Heart of New York

Artist: Christina Veragano
Patron: Max Capital Management Corp.
Location: 230 Park Avenue (at 46th Street)

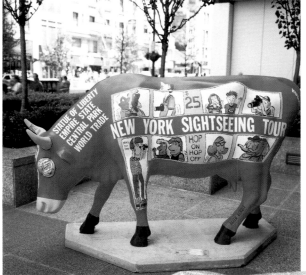

Sight Steer
(top left)

Artist: Keith Bendis
Patron: CowParade
New York 2000, Inc.
Location: One Penn Plaza
(34th Street between
Seventh and Eighth
Avenues)

The Hay-Team
(top right)

Artist: Ann Yzuel
Patron: TV Land
Location: One Penn Plaza
(34th Street between
Seventh and Eighth
Avenues)

Pixel Cow
(bottom)

Artist: Biff Elrod
Patron: CowParade
New York 2000, Inc.
Location: One Penn Plaza
(34th Street between
Seventh and Eighth
Avenues)

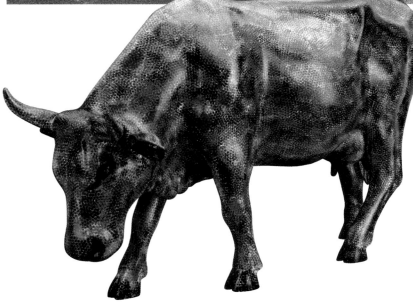

"THE PURPLE COW"
by F. Gelett Burgess

I never saw a purple cow.
I hope I never see one.
But I can tell you anyhow,
I'd rather see than be one.

The Thirties

Moozo the Taxi Cowb
(top left)

Artist: Jean R. Mazo
Patron: CowParade
New York 2000, Inc.
Location: Two Penn Plaza
(32nd Street and Seventh
Avenue)

Cowlage
(top right)

Artist: Janet Sorokin
Patron: CowParade
New York 2000, Inc.
Location: One Penn Plaza
(34th Street between
Seventh and Eighth
Avenues)

Cubist Cow
(bottom left)

Artist: Pauli Suominen
Patron: CowParade
New York 2000, Inc.
Location: One Penn Plaza
(34th Street between
Seventh and Eighth
Avenues)

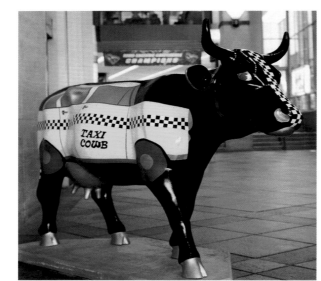

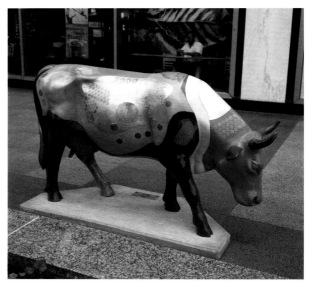

The Big Apple Cow
(left)

Artist: Janine Bolling, of
IS 78, School District 22
Patron: BASF
Location: Two Penn Plaza
(32nd Street and Seventh
Avenue)

Moo York, New York
(opposite page, bottom right)

Artist: Debra Priestly
Patron: HIP Health Plan of
New York
Location: One Penn Plaza
(34th Street between
Seventh and Eighth
Avenues)

Bess Bovine
(top left)

Artist: Jim DeCesare
Patron: Harlem
Globetrotters
Location: Two Penn Plaza
(32nd Street and Seventh
Avenue)

Wrestler Cow
(bottom left)

Artist: Arlette Jassel
Patron: United Paramount
Network
Location: Two Penn Plaza
(32nd Street and Seventh
Avenue)

City Cow
(bottom right)

Artist: Kim Sillen
Patron: Emigrant Savings
Bank
Location: Two Penn Plaza
(32nd Street and Seventh
Avenue)

Miss Macy Mae
(opposite page)

Artist: Macy's Parade
Studio
Patron: Macy's
Location: Macy's Herald
Square (inside store)

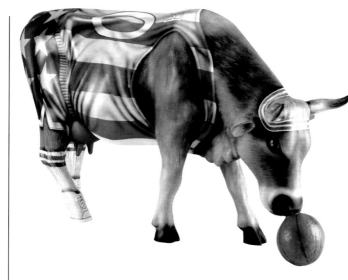

Jim DeCesare
Bess Bovine

In five weeks, Jim DeCesare cranked out not one but two cows. *Bess Bovine* is his salute to the Harlem Globetrotters. (That's a real basketball Bess is nosing, although DeCesare covered it with fiberglass "to maintain the integrity of the piece.")

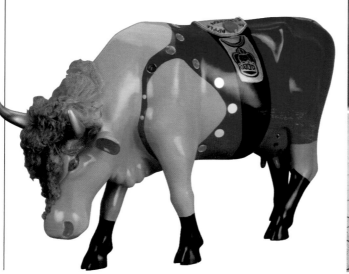

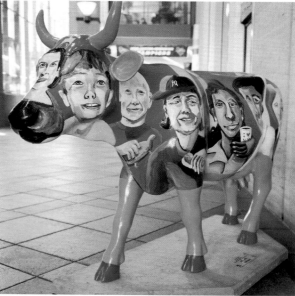

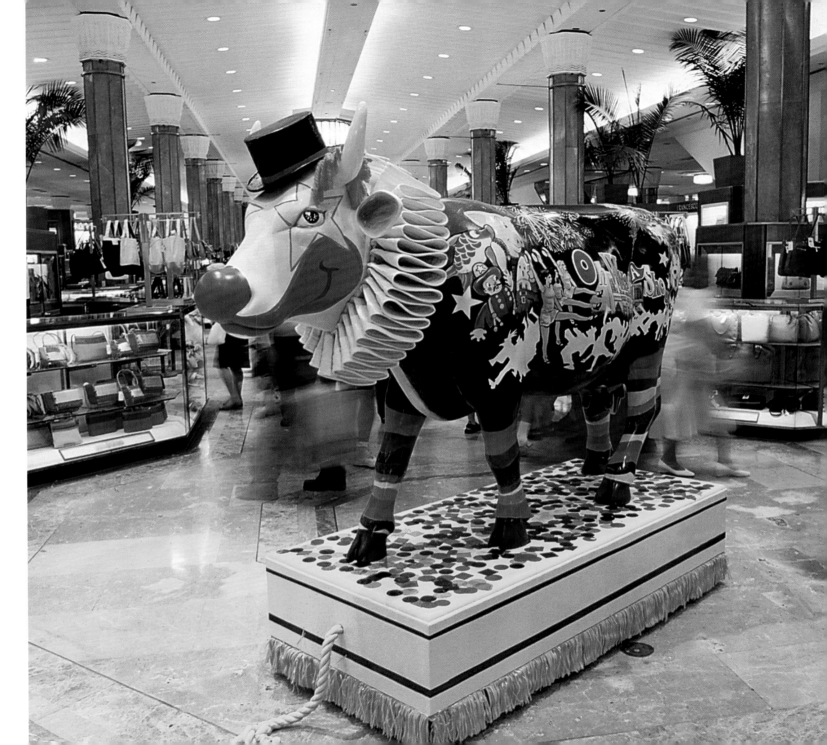

Rakow Warrior

Artists: Jim Brunelle and
Mike Dennan
Patron: CowParade
New York 2000, Inc.
Location: 90 Park Avenue
(at 39th Street)

Rakow Warrior **and** *Rakow* **by Jim Brunelle and Mike Dennan**

Take one look at the armored cow *Rakow Warrior* and it's hard not to think of this summer's sword-and-sandals blockbuster *Gladiator*. But artist Jim Brunelle says he and his collaborator, Mike Dennan, didn't have the

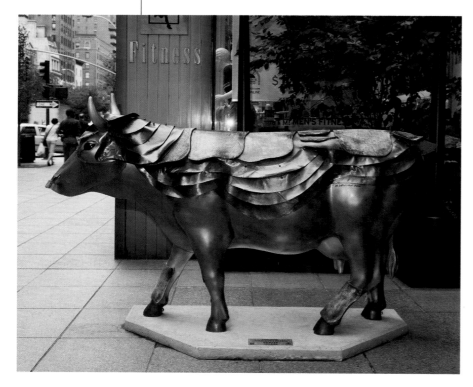

Russell Crowe movie in mind when they began. "It was just one of those fortuitous coincidences," Brunelle said.

Besides, *Rakow Warrior*'s inspiration was more Japanese samurai than Roman arena. Both Brunelle and Dennan use a Japanese ceramic technique known as *raku* in which molten pieces are removed from a 1900°F kiln and placed in a reduction chamber filled with highly flammable materials such as dried grass and pine needles. The rapid drop in temperature combined with the direct fire and smoke from the flammable materials produces fine crackling, interesting textures, and luminous colors.

Rakow's (page 84) tiles proved to be troublesome for Brunelle. The clay kept shrinking and shifting, and it was hard to find a way to attach the clay tiles, which are porous, to the fiberglass cow, which is nonporous.

Brunelle's solution was a construction adhesive called Liquid Nails—a name that inspires confidence. But just to be on the safe side, and to keep viewers from being tempted to pry off tiles as souvenirs, Brunelle filled in the spaces around the tiles with a kind of spackling cement. "I'm not certain if it will work," Brunelle mused. "The adhesive was still wet when I delivered the cow."

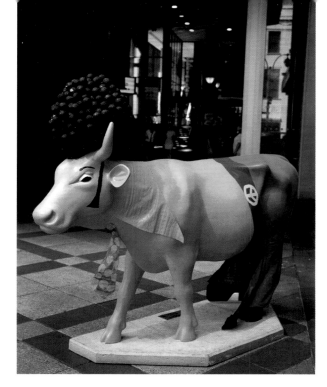

Afro Cow
(top left)

Artist: Keanna Hinds of IS 383, School District 32
Patron: BASF
Location: Two Penn Plaza (32nd Street and Seventh Avenue

Cows of Hearts
(top right)

Artist: Jim Ryan and National Down Syndrome Society Kids
Patron: Toys 'R' Us Children's Fund
Location: Greeley Square Park (Broadway at 32nd Street)

Cow Hide
(bottom)

Artist: Colette Anusewicz
Patron: CowParade New York 2000, Inc.
Location: 90 Park Avenue (at 39th Street)

Blue Moo
(top left and detail bottom left)

Artist: Mary Beth Whalen
Patron: CowParade
New York 2000, Inc.
Location: 41 Madison
Avenue (at 28th Street)

Cowcium
(right)

Artist: Bozell New York's
Creative Department
Patron: Bozell New York
Location: Madison Square
Park

Amoozon
Rain Forest
(opposite page)

Artist: Robert Markey
Patrons: Data-Mail, Inc.
and the Mandell family
Location: 41 Madison
Avenue (at 28th Street)

The Twenties

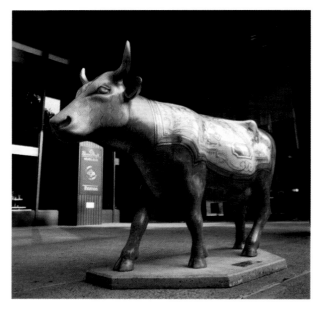

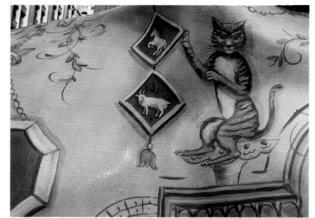

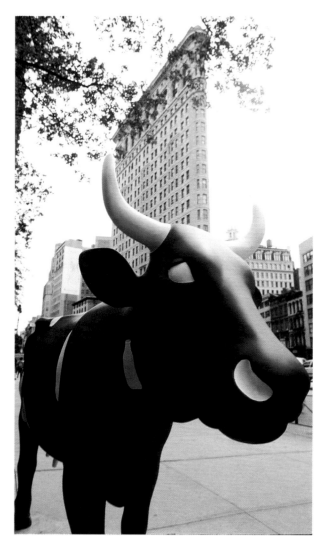

Robert Markey
Amoozon Rain Forest

For a decade Robert Markey was a sculptor. Then 10 or 12 years ago he felt the need to paint, so he combined his two talents by painting sculpture. Recently he painted a female torso, covered it with flowers, entwined a snake around her neck, and called the work *Eve*. "That's what gave me the idea for the cow," Markey said.

"I planned something that would be really colorful from far away," he said, "and really interesting way up close." From a distance the viewer sees the lush flowers and vegetation of the rain forest, but closer inspection reveals such little pleasures as ants, spiders, and lizards hidden amid the foliage. And if you look into the cow's eyes, you can see two indigenous people peering out.

HOW TO SAY MOO IN SIX LANGUAGES

1. French: *Meuh*
2. German: *Muh*
3. Italian: *Mu!*
4. Portuguese: *Muuu*
5. Japanese: *Mo* (pronounced "mow")
6. Hebrew: *Go'eh*

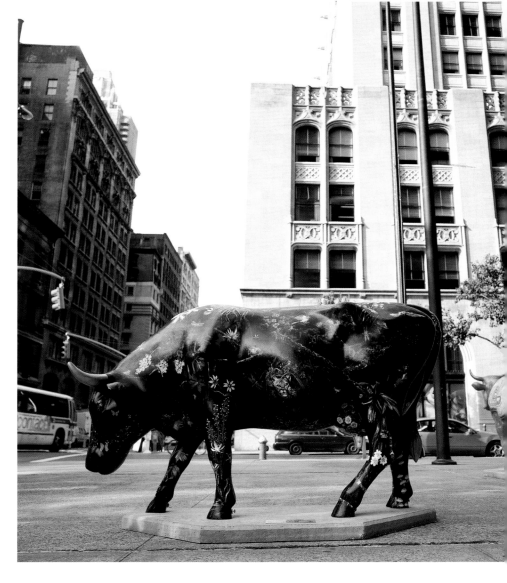

UPPER WEST SIDE

RECORD-SETTING COWS

The Best Milk-Producing Cow: Holstein; holds the record for milk production—67,914 pounds milk in one year.

Hearst Magazines. We Read America

Artist: Harman
Sponsor: Hearst Magazines
Location: Columbus Circle (59th Street and Central Park West)

the epicenter of New York City's current baby boom is the Upper West Side. On any given sunny Saturday, the sidewalks of Broadway are jammed with pricey strollers. So if there's anyplace in Manhattan where cows—the emblem of all that's natural and nurturing—will be welcome, it's this part of town.

With its beautiful residential side streets, easy access to Central Park, and lots of action on Broadway and Columbus Avenue, the Upper West Side has been a favorite location for filmmakers for years. The neighborhood has served as the setting for scenes from *Wall Street, When Harry Met Sally, Three Men and a Baby,* and just about every Woody Allen movie. It was the location for the TV comedy hit *Seinfeld,* and for the current HBO series *Sex and the City.* The grand Dakota apartment building on Central Park West became the setting for Ira Levin's bestseller *Rosemary's Baby;* in real life, John Lennon was murdered as he entered the Dakota in 1980.

The Upper West Side has always attracted celebrities. Igor Stravinsky, Enrico Caruso, Lily Pons, and Arturo Toscanini lived in the Ansonia on Broadway. Edna Ferber wrote *Show Boat* in her apartment on Central Park West. George and Ira Gershwin, Sergey Rachmaninoff, and William Randolph Hearst were neighbors on Riverside Drive. Rudolph Valentino, Ben Hecht, Robert Lowell, Berenice Abbott, Isadora Duncan, and Norman Rockwell called West 67th Street home. The neighborhood has also been home to General William Tecumseh Sherman, Elizabeth Cady Stanton, Virginia O'Hanlon (as in "Yes, Virginia, there is a Santa Claus"), Anaïs Nin, Fanny Brice and Nicky Arnstein, Billie Holiday, Norman Mailer, Isaac Bashevis Singer, and Leonard Bernstein.

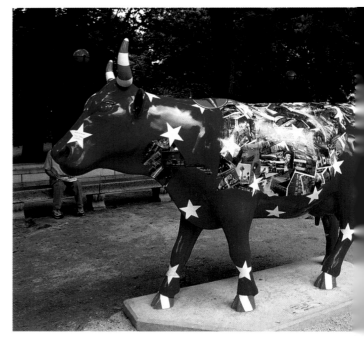

Columbus Circle

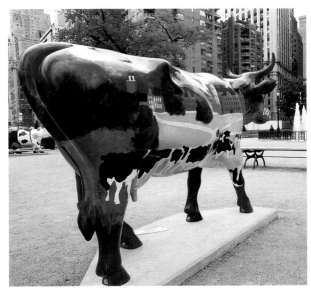

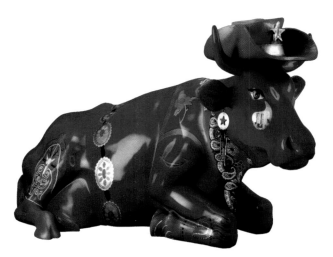

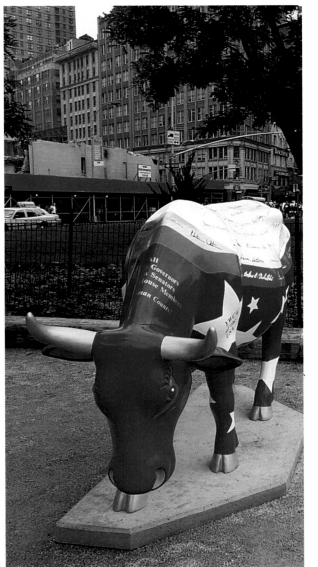

Green Mountain Cow
(top left)

Artist: Woody Jackson
Patron: University of Vermont
Location: Columbus Circle (59th Street and Central Park West)

Women on the Moo
(right)

Artist: Silk Fish Design, Inc.
Patron: Lifetime, Television for Women
Location: Columbus Circle (59th Street and Central Park West)

Even Cowgirls Get the Blues
(bottom left)

Artist: Denise Shaw
Patron: Jane Forbes Clark
Location: Columbus Circle (59th Street and Central Park West)

Bovine Fetch

Artists: M. Igoe, J. Brucker-Cohen, R. Ho, T. Igoe, M. Petit, M. Yasuda
Patron: CowParade New York 2000, Inc.
Location: Columbus Circle (59th Street and Central Park West)

Tom Igoe *Bovine Fetch*

Tom Igoe teaches at the interactive telecommunications program at NYU's Tisch School of the Arts. His specialty is building responsive public art in which the viewer actually becomes part of the artwork. Typically, Igoe uses light and heat sensors that go off when a viewer gets close to or touches the work. "It's interactive stuff," Igoe said. "The sensors make the artwork change as you view it."

Although he considered hooking up *Bovine Fetch* with sensors, in the end Igoe and his five collaborators settled for a low-tech cow. But they drew their inspiration from close to home—the urbanfetch messengers and East Village kids Igoe and his friends see hanging around NYU every day. Hence the tattoos, the nose stud, the piercings in two teats, and the cow-size skateboard.

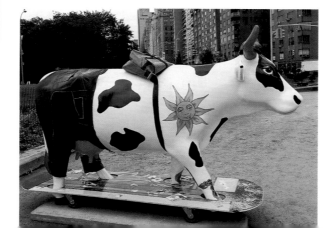

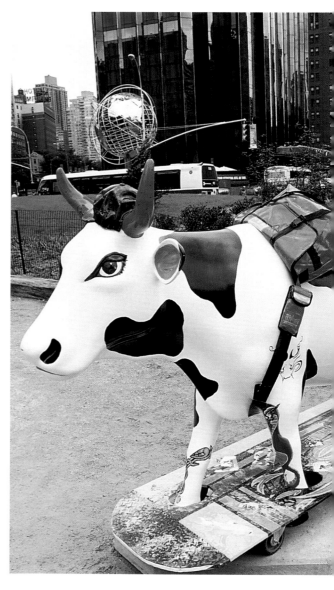

Lincoln Center

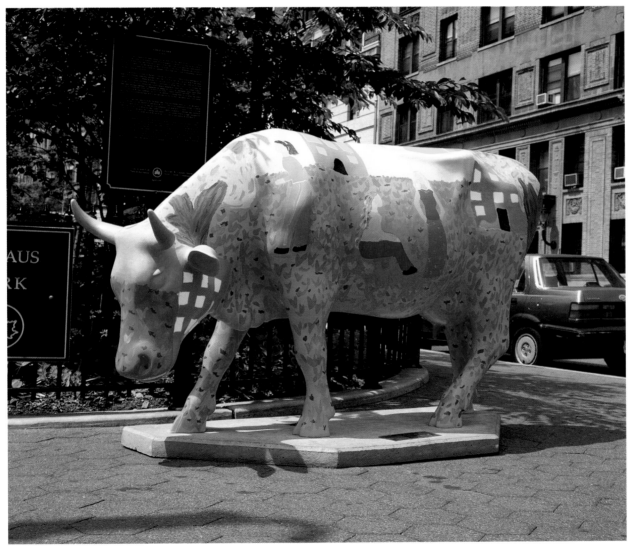

NYC Summer Fashion

Artist: Eglish Perez, of Dual Language MS, School District 3
Patron: BASF
Location: Straus Park (Broadway at 106th Street)

Cows can identify a smell up to five miles away.

eCow—Defender of the Global Village
(top)

Artist: Jerard Studio
Patron: Aladdin Knowledge Systems
Location: Central Park West at 72nd Street

A Moo York Neighborhood
(bottom left and right)

Artist: Allison Beispel
Patron: North Fork Bank
Location: 175 West 72nd Street (inside bank)

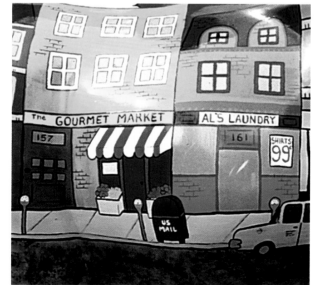

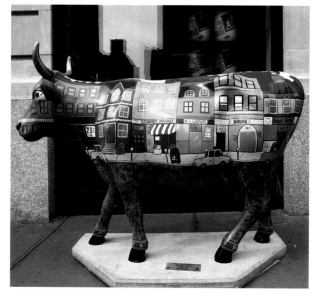

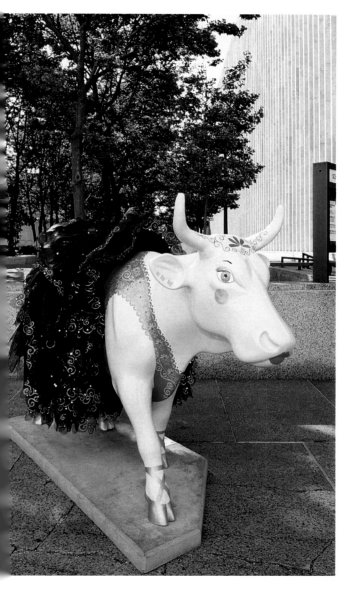

Pam Weltman
Prima Cowerina

It was Pam Weltman's niece from Chicago that first told her about CowParade.

Weltman had worked for years as a fashion illustrator before she left her job to raise her children. Even with the demands of family life, she still drew and painted. "I did a lot of pro bono stuff," she said, "and I painted things—chairs, stools, pottery."

Since Weltman associates New York City with the arts, she wanted to do a cow that had a cultural connection. *Prima Cowerina* was born from that nugget of an idea, combined with Weltman's fashion background and her childhood ballet lessons.

The tutu was constructed of 250 feet of fiberglass screen, every inch of it hand-painted and hand-rhinestoned by Weltman. For technical advice on how to get the rhinestones to adhere, she consulted an expert in California who calls himself the Rhinestone Guy.

It took Weltman three months of intense work to complete her cow. "This cow is huge!" Weltman said. "You have no idea how big it is until you start painting it with a Number 1 brush."

Prima Cowerina

Artist: Pam Weltman
Patron: CowParade
New York 2000, Inc.
Location: Lincoln Center
(South Plaza)

Mooving Uptown

Artist: Alexa Halper, of
JHS 157, School District 28
Patron: BASF
Location: Central Park West
at 97th Street

KEY COW FACTS

It takes a gallon-and-
a-half of milk to make
one gallon of ice
cream.

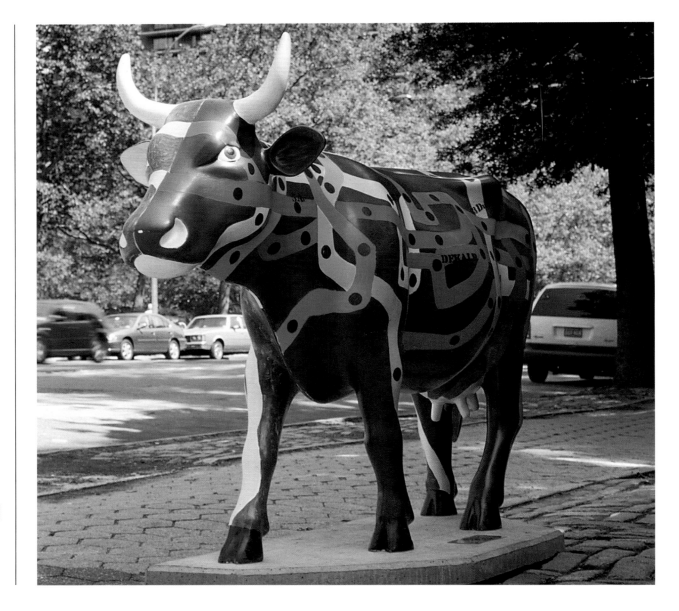

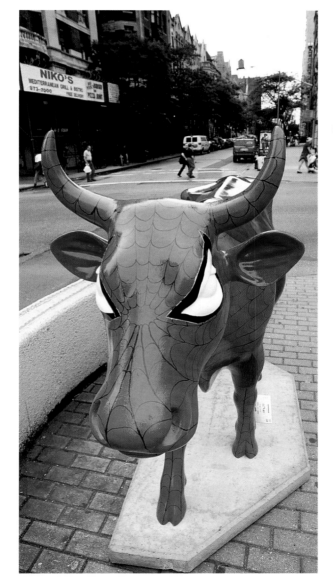

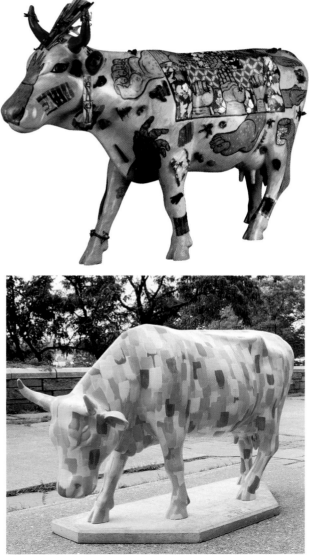

Spider Cow
(left)

Artist: Andy Cesana
Patron: UBS AG
Location: Broadway Mall
at 77th Street

Sacred Cow #3
(top right)

Artist: Sasha Chavchavadze
Patron: RCN Corporation
Location: Broadway Mall
at 68th Street

Publicolorcow
(bottom right)

Artists: Ruth Shuman,
Publicolor Students and
Staff
Patron: Benjamin Moore
Location: Riverside Park
Promenade

Strawberry Milkshake Cow
(top left)

Artist: Mary Trevor, art teacher of IS 162, School District 7
Patron: BASF
Location: Central Park West at 72nd Street

Rakow
(top right)

Artists: Jim Brunelle and Mike Dennan
Patron: CowParade New York 2000, Inc.
Location: Morningside Park (110th Street and Morningside Drive)

Mooving on Up
(bottom)

Artist: Jenny M. Steinman
Patron: CowParade New York 2000, Inc.
Location: Inwood Hill Park (at 218th Street)

Diana Freedman-Shea
Vincent Van Cogh

Vincent Van Cogh
Artist: Diana Freedman-Shea
Patron: CowParade New York 2000, Inc.
Location: Riverside Park Promenade

Diana Freedman-Shea is a representative painter and print maker. While she has never depicted cows before, other types of animals have been on her mind lately. "My latest series of etchings were of apes," she said, "and I had my prints of elephants displayed in the Elephant House at the Bronx Zoo."

Freedman-Shea's idea for *Vincent Van Cogh* is based on a kind of reversal: "I always think of cows being on a farm, so I wondered what it would be like to have a farm be on a cow."

Freedman-Shea chose a favorite Van Gogh painting of a Provençal farm. She took a detail from the painting (the section closest

to the horizon) and let the hills drape from the bones of the cow's back. Then, to achieve what she describes as Van Gogh's "brushiness," Freedman-Shea used a gel medium and lots of layerings of colors.

Beast of Light

Artist: Peter Kitchell
Patron: CowParade
New York 2000, Inc.
Location: Inwood Hill Park

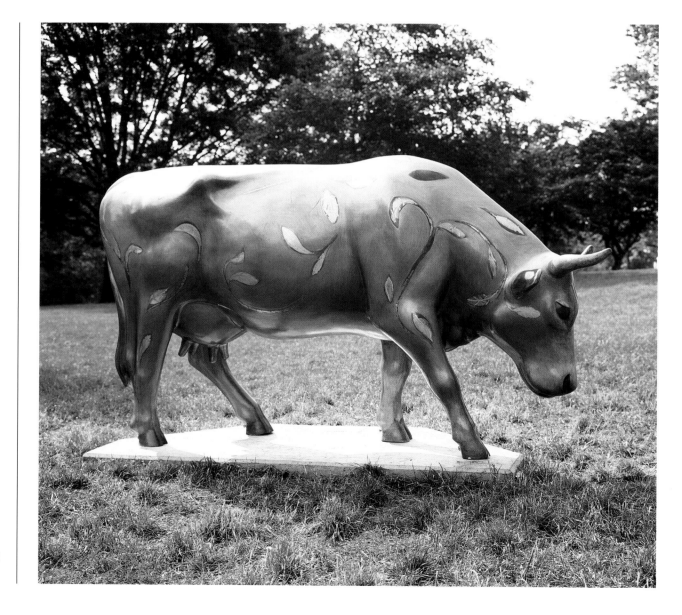

 Cows can
see color.

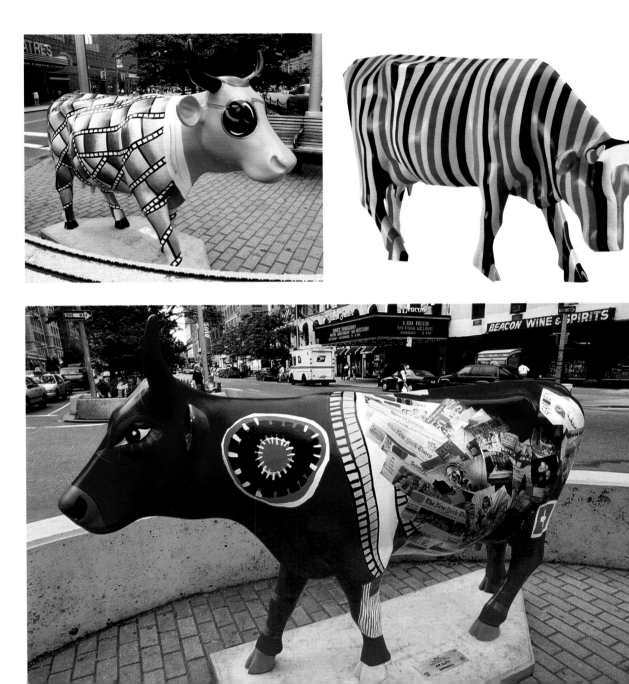

Moovie Cow
(top left)

Artist: Orianna DeMasi
Patron: Emigrant Savings Bank
Location: Broadway Mall at 68th Street

Striped Cow
(top right)

Artist: Cary Smith
Patron: CowParade New York 2000, Inc.
Location: Tucker Park (Broadway at 66th Street)

Rosa
(bottom)

Artist: Garance
Patron: Muller-Martini
Location: Broadway Mall at 74th Street

Stone Wall Cow
(top)

Artist: Peter Waite
Patron: CowParade
New York 2000, Inc.
Location: Central Park West
at 75th Street

Pull Toy
(bottom)

Artist: Norm Magnusson
Patron: CowParade
New York 2000, Inc.
Location: Riverside Park
Promenade

Cow Word
(opposite page, top left)

Artist: Ilona Levitz
Patron: CowParade
New York 2000, Inc.
Location: Morningside Park
(110th Street and
Morningside Drive)

HOLY COWS! IRELAND

A 5th-century Irish nun, St. Brigid of Kildare, is said to have been a milkmaid before she entered the convent. According to legend, the small herd of cows she kept at Kildare produced a whole lake of milk every day. In Ireland, St. Brigid is venerated as the patron saint of dairy farmers.

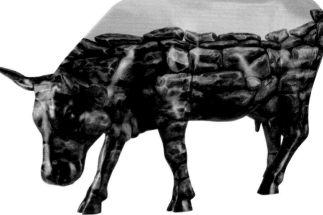

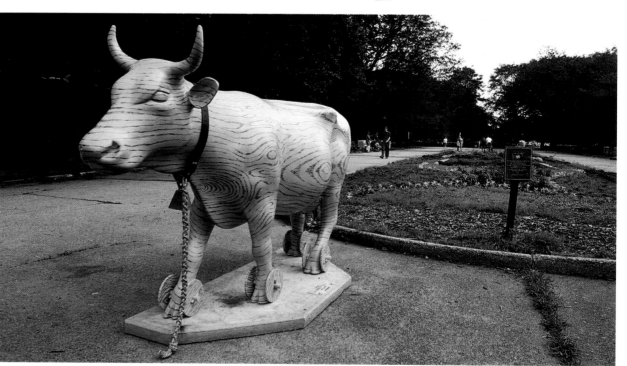

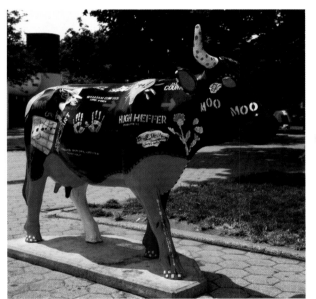

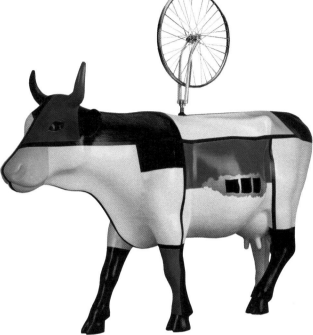

MOOMA
(top right)

Artists: Karen Nelson and Nicole Gaenzler
Patron: CowParade New York 2000, Inc.
Location: Riverside Park Promenade

Landscape Cow
(bottom left)

Artist: Romero Britto
Patron: CowParade New York 2000, Inc.
Location: Dante Square (Broadway between 63rd and 64th Streets)

Mooodama Butter-fly
(bottom right)

Artist: Lisa di Prima
Patron: Emigrant Savings Bank
Location: Lincoln Center (North Plaza)

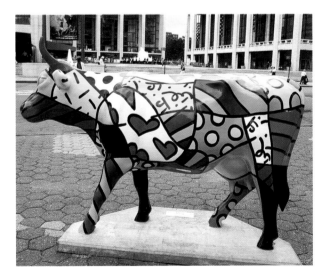

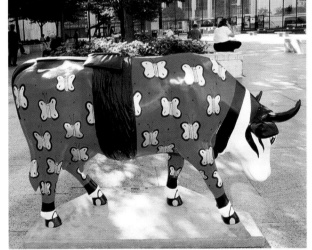

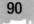
UPPER EAST SIDE

Heart of New York

Artists: Jully Li and Jenny Kononenko, of IS 239, School District 21

Patron: BASF

Location: John Jay Park (77th Street east of York Avenue)

RECORD-SETTING COWS

The Smallest Cow: Dexter; stands about three feet high.

t‍he Upper East Side is New York at its most genteel. Its main shopping thoroughfare, Madison Avenue, is lined with designer boutiques and pricey bistros. On the East Side's serene side streets you'll find some of the most beautiful mansions and townhouses in Manhattan. The cows who mosey into this part of town had better be on their best behavior.

For decades New York's high society has called the Upper East Side its own. Jacqueline Kennedy Onassis grew up here and spent the last years of her life on the East Side. William Paley, founder of CBS, lived in a 20-room duplex on Fifth Avenue. Marjorie Merriweather Post Hutton lived just up the street. A house on East 61st Street was the home first of Alice Roosevelt Longworth (Teddy Roosevelt's daughter), then critic Clifton Fadiman, and finally actor Montgomery Clift. Newlyweds Franklin and Eleanor Roosevelt lived in a house on East 65th Street. One block away were the Havemeyers, who possessed one of the world's greatest private art collections, which they donated in 1929 to the Metropolitan Museum of Art. Another philanthropist, Andrew Carnegie, and his ex-partner Henry Clay Frick built dueling mansions on Fifth Avenue.

Grand Army Plaza

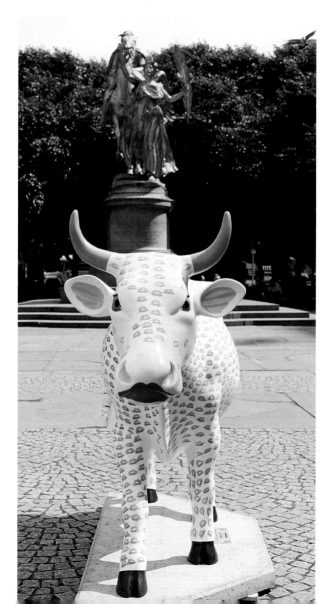

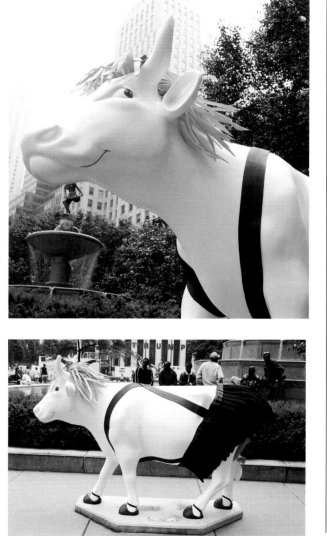

sMOOch
(left)

Artist: Kris Henderson
Patron: Estée Lauder Go Pout Lipcolor
Location: Grand Army Plaza (Fifth Avenue at 58th Street)

Moooooooooo It's Me, ELOISE
(right, top and bottom)

Artists: Hilary Knight and Geppetto Studios Inc. (based on Kay Thompson's *Eloise* ©2000 by the Estate of Kay Thompson)
Patron: Simon & Schuster Children's Publishing
Location: Grand Army Plaza (Fifth Avenue at 58th Street)

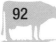

Frida Stare

Artist: Linda Dolack
Patron: Stuart Weitzman
Location: Grand Army Plaza
(Fifth Avenue at 58th Street)

Ginger Rhinestone

Artist: Linda Dolack
Patron: Stuart Weitzman
Location: Grand Army Plaza
(Fifth Avenue at 58th Street)

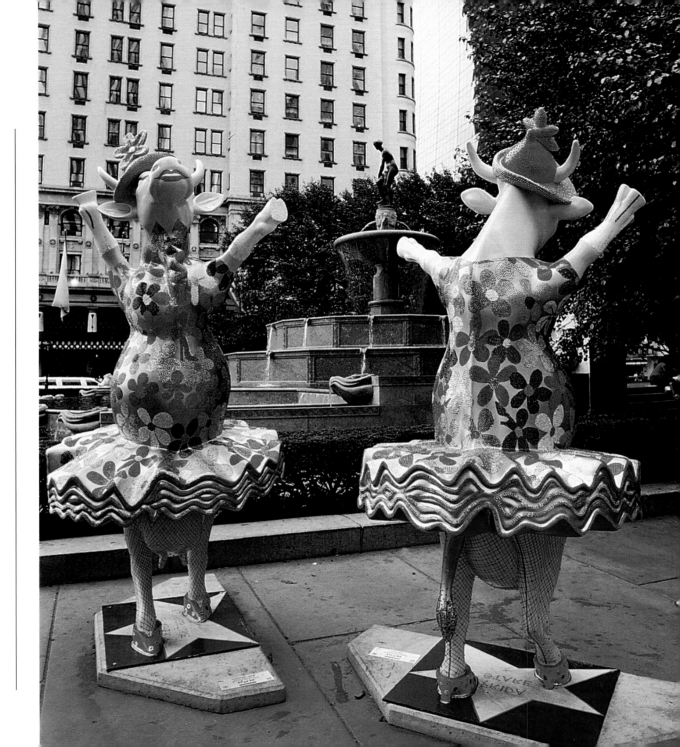

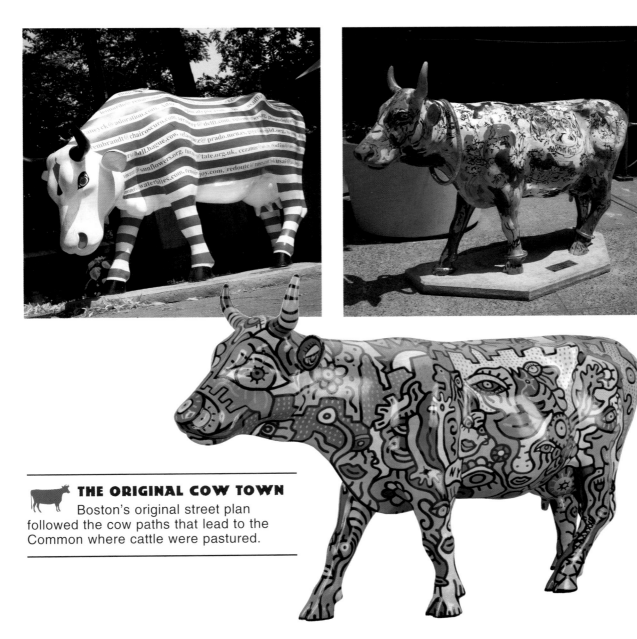

emoo.cow
(top left)

Artist: Michael Langenstein
Patron: CowParade
New York 2000, Inc.
Location: Marcus Garvey
Park (Madison Avenue at
120th Street)

The Cow That Wants to be a Horse
(top right)

Artist: Scherezade
Patron: The Bravo Group
Location: courtyard of El
Museo del Barrio, 1230
Fifth Avenue (at 105th
Street)

Moo York Celebration
(bottom)

Artist: Billy
Sponsor: CowParade
New York 2000, Inc.
Location: Grand Army Plaza
(Fifth Avenue at 58th Street)

THE ORIGINAL COW TOWN
Boston's original street plan followed the cow paths that lead to the Common where cattle were pastured.

The Purple Cow
(top)

Artists: The Children of the Neighborhood
Patron: DNJ-MOJ
Location: Fifth Avenue at 69th Street

Harem in Heifer
(bottom left)

Artist: Patricia Nix
Patron: CowParade New York 2000, Inc.
Location: Fifth Avenue at 91st Street

Circuit Cow
(bottom right)

Artist: Charles Foster-Hall
Patron: CowParade New York 2000, Inc.
Location: Marcus Garvey Park (Madison Avenue at 120th Street)

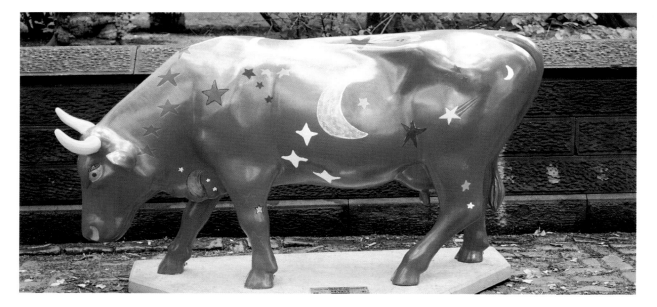

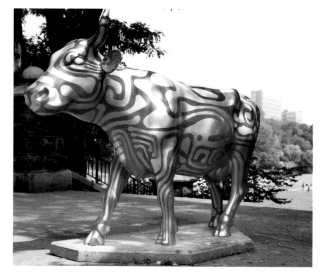

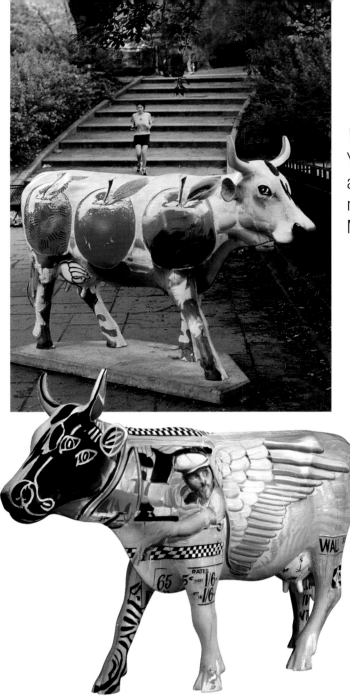

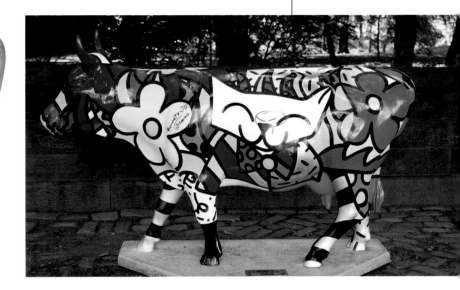

Now Cow 2000 is an udder New Yorker. She has big apples all over one side and a Checker cab on the other. Not to mention that she lives very close to Gracie Mansion, the mayor's residence.

Now Cow 2000
(top and bottom left)

Artist: Paul Giovanopoulos
Patrons: Robert and Barbara Wagner
Location: Carl Schurz Park (at 86th Street and East End Avenue)

Dog and Cat Cow
(bottom right)

Artist: Romero Britto
Patron: Sundook Galleries, Boca Raton, Florida
Location: Fifth Avenue at 77th Street

Fancy Cow
(top)

Artist: Stephanie Patton
Patrons: Zitomer and
Zitomer Z Spot
Location: Fifth Avenue
at 75th Street

Tiffany Cow
(bottom left)

Artists: Adele Moros,
Bethel Arts Junction
Patron: Emigrant Savings
Bank
Location: Carl Schurz Park
(at 86th Street and East
End Avenue)

Untitled
(bottom right)

Patron: CowParade
New York 2000, Inc.
Location: Ruppert Park
(Second Avenue at 90th
Street)

HOLY COWS! NORSE MYTH

Norse mythology tells how the Great Cow, Audhumla, brought gods and giants into existence by licking the huge blocks of ice in which they had been imprisoned.

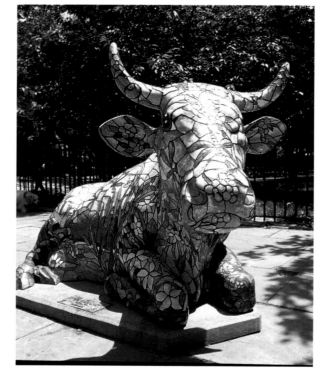

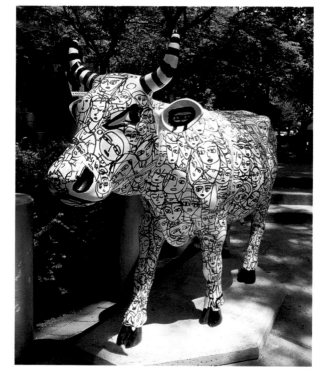

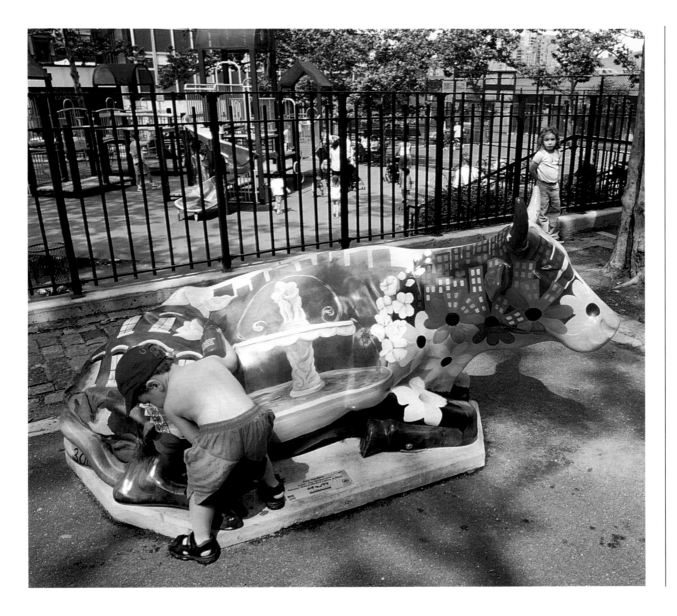

City Gardens

Artist: Vita Mechachonis
Patrons: Animal Medical Center and Pfizer
Location: 24 Sycamores Playground (between York Avenue and FDR Drive at 60th Street)

CENTRAL PARK

Sand Castle Cow
(left)

Artist: Nina Yankowitz
Patron: Bahamas Ministry of Tourism
Location: Wein Walk (near Fifth Avenue and 60th Street)

Daisy
(right)

Artist: Lisa Pliner
Patron: Donald J. Pliner
Location: Wein Walk (near Fifth Avenue and 60th Street)

Cows on Rollerblades. Cows on bikes. Cows jogging around the Reservoir. Cows playing frisbee in the Sheep Meadow. Cows lining up for tickets to Shakespeare in the Park. Cows rowing on the lake. Central Park is cow arcadia.

As early as 1840 civic leaders in New York recognized the importance of a large public park, but it was not until 1856 that the Central Park Commission acquired land in the center of Manhattan and began planning a vast park. Frederick Law Olmsted and Calvert Vaux were hired to design what would be the first landscaped public park in America.

First the city cleared out 1,600 residents who lived in tiny communities on the site. Then it hired 20,000 workers to blast bedrock, drain swamps, divert streams, and create lawns and meadows. One of Olmsted and Vaux's visionary innovations was building sunken crossroads so traffic would not intrude upon the pleasures of the park—and they did this decades before the automobile had been invented.

The park has been the scene of a host of memorable moments—from the erection of the Egyptian obelisk Cleopatra's Needle, to live concerts by Paul Simon, Luciano Pavarotti, and Diana Ross, to a papal Mass offered by John Paul II. And every fall the park is the finish line for the New York Marathon.

Carousel Cow

Artist: Adele Moros—
Bethel Arts Junction
Patron: Jane Forbes Clark
Location: the Carousel
(65th Street Transverse and
Center Drive)

Sacred Cow #5

Artist: Sasha Chavchavadze
Patron: RCN Corporation
Location: Central Park Zoo,
southern entrance

HOLY COWS! INDIA

It is said that the god Brahma created cows to provide the priestly brahmin caste with ghee, the clarified butter necessary for Hindu rituals. Out of respect for their sacred function, devout Hindus will not harm or kill a cow.

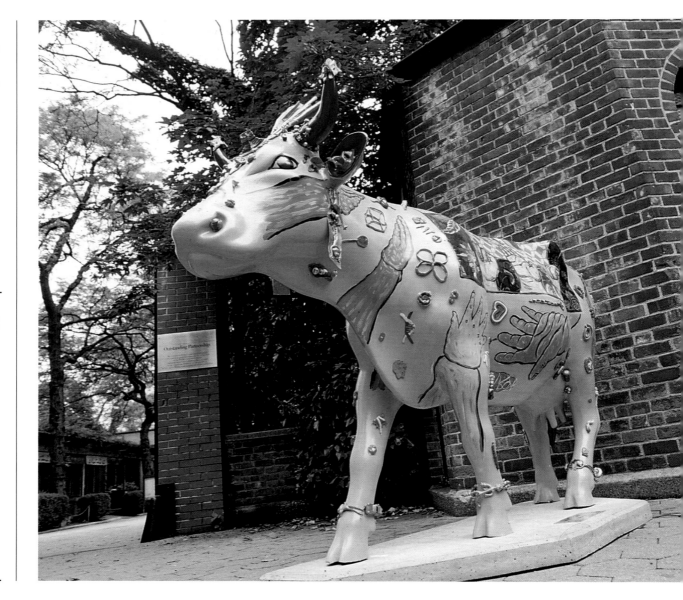

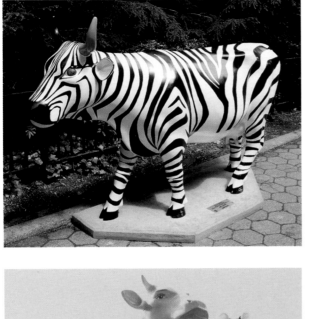

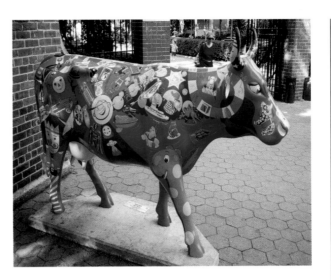

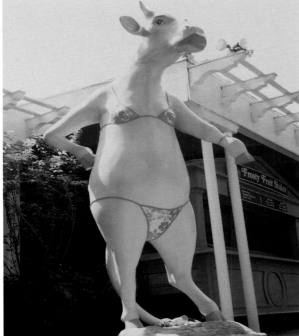

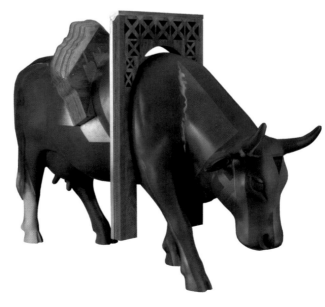

The Greenhorn
(top left)

Artist: Susan Roecker
Patron: CowParade
New York 2000, Inc.
Location: Central Park Zoo,
the promenade

Joy To Toys!
(top right)

Artist: Anthony Freda
Patron: Commonwealth Toy
& Novelty Co., Inc.
Location: Central Park Zoo,
southern entrance

Orchid
(bottom left)

Artist: Crocket Effects
Patron: J. Crew
Location: Boathouse area

A Street Cow
Named Desire
(bottom right)

Artist: Edwin M. Owre
Patron: University of
Vermont
Location: the Dairy (65th
Street, west of the Zoo)

Udderly Shakespeare in the Park

Artist: Holly Beckett
Patron: CowParade New York 2000, Inc.
Location: Delacorte Theater (80th Street east of West Drive)

Holly Beckett *Udderly Shakespeare in the Park*

Holly Beckett has two passions—making collages from found objects and collecting old books. At a sale of old books not long ago, she discovered a beautiful leather cover with gold embossing: *The Complete Works of Shakespeare*. Just the cover, mind you, not the whole book. "I bought it because I thought it would look great in a collage," Beckett said. "Then I found the rest of the book that had been separated from the cover, so I thought what the heck and I bought that, too."

The typesetting of the antique Shakespeare was beautiful, and while Beckett was contemplating how to use the lovely pages in a collage, she heard about CowParade. She submitted a proposal to cover a cow with the complete works of Shakespeare.

"The book's title page is on the cow's nose," Beckett said. "*All's Well That Ends Well* is on its butt."

The look is udderly Shakespearean.

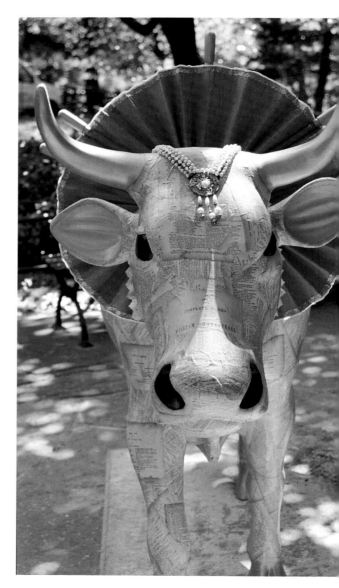

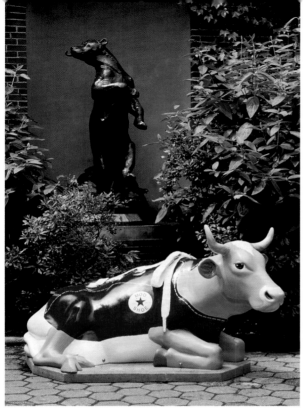

MooShoe
(top left)

Artist: Iris Rosenberg
Patron: CowParade
New York 2000, Inc.
Location: Children's Zoo
(Fifth Avenue at 65th Street)

All-D the Cow
(top right)

Artist: Darry Romano
Patron: AT&T Corporation
Location: Mineral Springs
(70th Street east of West
Drive)

King Kow
(bottom left)

Artist: Tim Chu
Patron: CowParade
New York 2000, Inc.
Location: Conservatory
Water (west of Fifth Avenue
between 73rd and 75th
Streets)

Party Cow
(bottom right)

Artists: Studio 2, Pattie
Gaeta and Luci Rawding
Patron: CowParade
New York 2000, Inc.
Location: the Dairy (65th
Street, west of the Zoo)

Cowtopia

Artist: Cynthia Chan
Patron: Jane Forbes Clark
Location: Central Park Zoo, promenade

KEY COW FACTS

There are 92 different breeds of cows in the world.

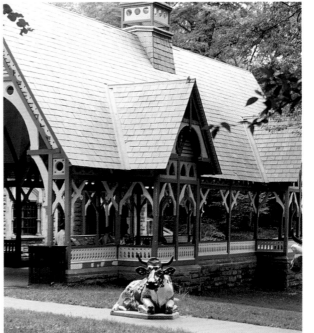

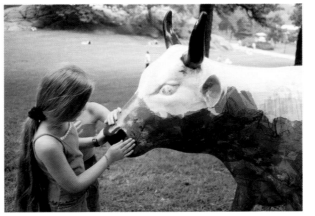

Claude Mooonet
(left)

Artist: Joseph A. Galluccio
Patron: CowParade
New York 2000, Inc.
Location: Metropolitan
Museum of Art area

Picnic
(top right)

Artist: Cynthia Gale
Patron: MarComm Partners
Location: the Dairy (65th
Street, west of the Zoo)

New York Pasture
(bottom right)

Artist: Morton Kass
Patron: Emigrant Savings
Bank
Location: the Dairy (65th
Street, west of the Zoo)

Flower Power Cow-ard

Artist: Chris Plecs
Patron: Tavern on the Green
Location: Tavern on the Green (67th Street and Central Park West)

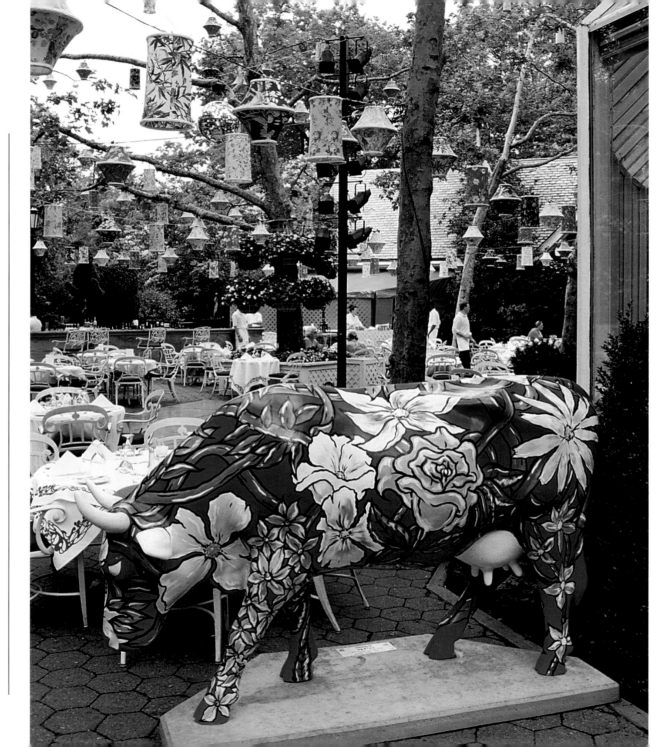

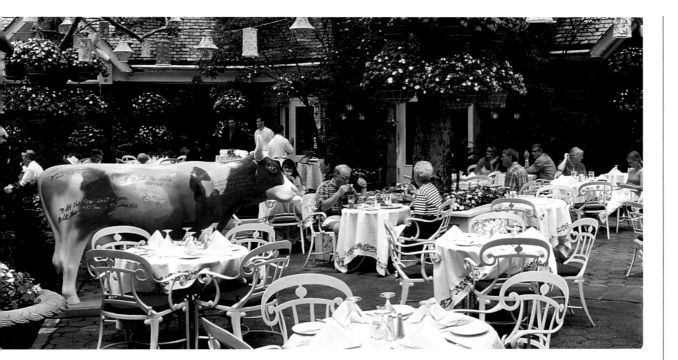

The Bovine Beauty
(left)

Artist: LeRoy Neiman
Patron: Tavern on the Green
Location: Tavern on the Green (67th Street and Central Park West)

Play Ball 2000
(bottom left)

Artist: Jacqueline Freedman
Patron: Jane Forbes Clark
Location: Heckscher Ballfields (63rd Street between Center and West Drives)

Flower Power Cow
(bottom right)

Artist: Romero Britto
Patron: Pop International, New York City
Location: Metropolitan Museum of Art area

Cowapatra
(top left)

Artist: Jennifer Spence, art teacher of PS 5, School District 7
Patron: BASF
Location: Cleopatra's Needle area (82nd Street and East Drive)

No Milk Today: Cow Gone Fishin'
(bottom)

Artist: Nancy Kramer Potanka
Patron: CowParade New York 2000, Inc.
Location: Harlem Meer (Fifth Avenue at 106th Street)

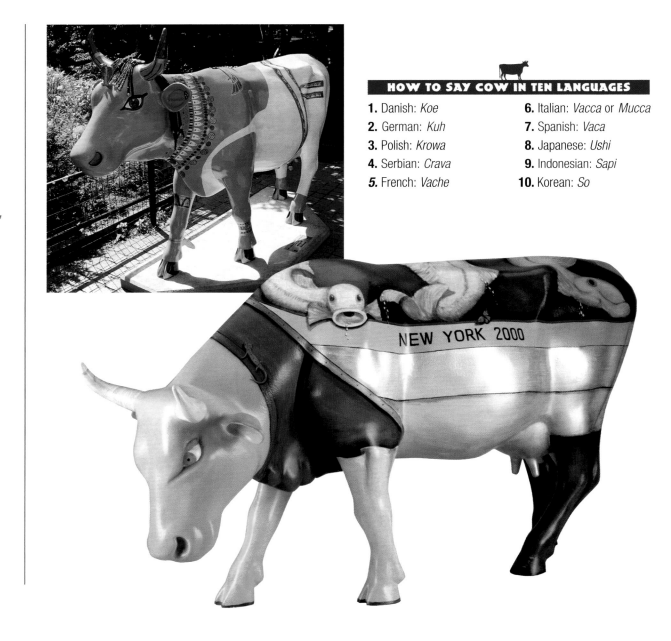

HOW TO SAY COW IN TEN LANGUAGES

1. Danish: *Koe*
2. German: *Kuh*
3. Polish: *Krowa*
4. Serbian: *Crava*
5. French: *Vache*
6. Italian: *Vacca* or *Mucca*
7. Spanish: *Vaca*
8. Japanese: *Ushi*
9. Indonesian: *Sapi*
10. Korean: *So*

Dennis Peabody
Tutancowmon

Dennis Peabody is an artist who works in flat glass, particularly dichromic glass, which has an iridescent, gemlike quality. Not surprisingly, his first thought was to encrust his cow with this type of glass. "Then I realized how very expensive and very tedious that would be," Peabody said.

So he scaled down his ambitions, and that's when the idea of an Egyptian-theme cow occurred to him: "I thought of all the Egyptians I knew and remembered Tutankhamun. Or, I should say, Tutancowmon."

Peabody admits that he's not really a sculptor. Consequently, creating the distinctive pharaohesque headpiece was a challenge. He

started by building a plywood armature for the neck, then covering it with chicken wire and plaster gauze. At every stage of building the headpiece the artist was flooded with doubt. What was his biggest fear? "I didn't want it to come out like a bad high-school project."

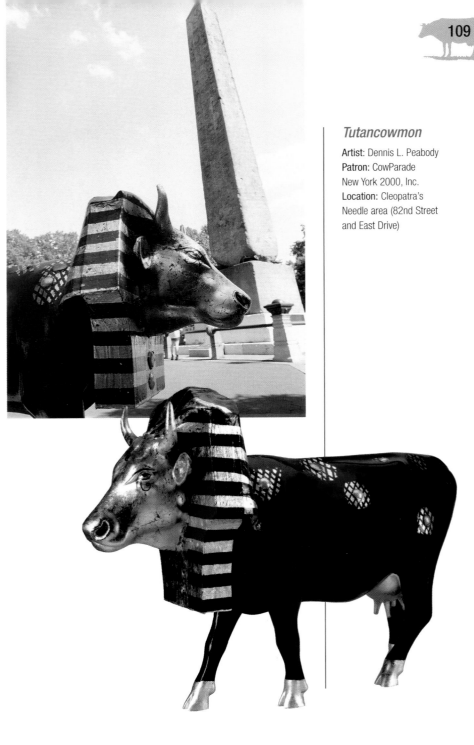

Tutancowmon
Artist: Dennis L. Peabody
Patron: CowParade New York 2000, Inc.
Location: Cleopatra's Needle area (82nd Street and East Drive)

Puzzled Cow
(top)

Artist: Jason Middlebrook
Patron: CowParade
New York 2000, Inc.
Location: 85th Street
Playground area

*New York Road
Cow Racer*
(bottom left)

Artist: Nancy Kramer
Potanka
Patron: CowParade
New York 2000, Inc.
Location: Reservoir area

Leopard Cow
(bottom right)

Artist: Dee Shapiro
Patron: CowParade
New York 2000, Inc.
Location: Central Park
Zoo, promenade

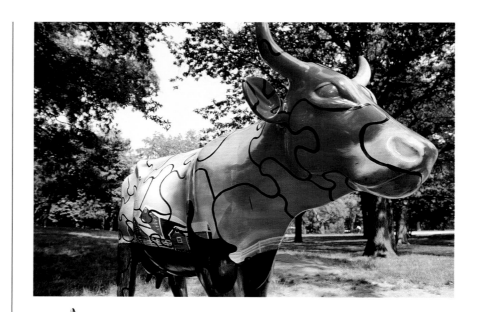

 WHOA, DADDY!

Artificial insemination accounts for 85 percent of all Holstein births. Thanks to artificial insemination, one Holstein bull can sire 50,000 offspring.

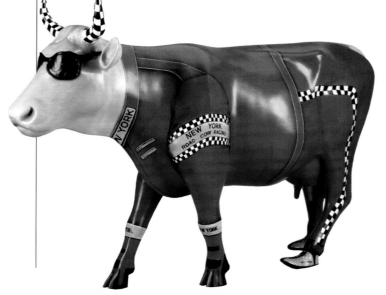

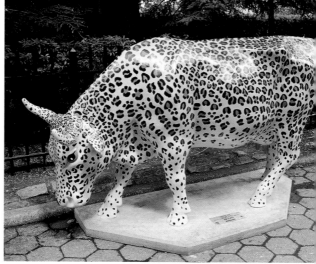

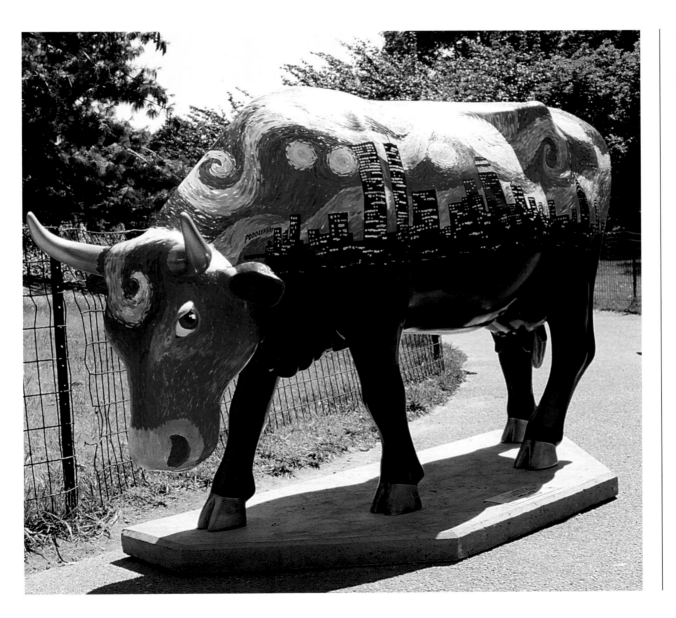

A Starry Night Cow

Artist: Mabel Podolefsky
Patron: Emigrant Savings Bank
Location: Metropolitan Museum of Art area

BOROUGH BOVINES

Sacred Cow #2

Artist: Sasha Chavchavadze
Patron: RCN Corporation
Location: Cadman Plaza

KEY COW FACTS

A cow has four stomachs. The first, the rumen or paunch, is where the food goes when a cow swallows. Once the rumen has softened up the food, it is regurgitated to be chewed as cud. When the cow swallows the cud, it goes to the second stomach, the reticulum or honeycomb. The process of swallowing, regurgitating, and chewing cud is repeated in the third stomach, the omasum or manyplies, until at last the food is digested in the fourth stomach, the abomasum.

i t's easy to think of New York as all skyscrapers and screeching taxis. Many people forget that Manhattan is just a small part of New York City, which comprises five boroughs: Manhattan, Brooklyn, Queens, the Bronx, and Staten Island. Manhattan is, in fact, the smallest of the boroughs, occupying only 34 square miles. Queens may occupy the largest territory, weighing in at 126 square miles, but Brooklyn wins the population contest. With 2.3 million people, if Brooklyn were its own city it would be America's fourth largest.

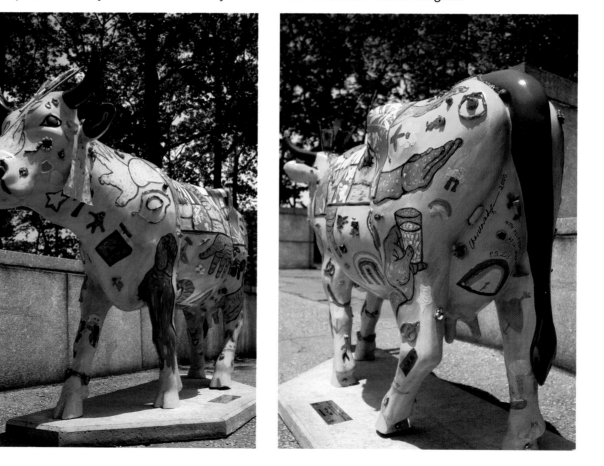

Brooklyn

At the end of the 18th century, as farmland in lower Manhattan became scarce, diary farmers ferried their cows across the East River to the peaceful rural town of Brooklyn. But every morning the farmers came back to Manhattan to sell their milk, cream, butter, and cheese. Today Brooklyn is still one of the city's prime commuter boroughs, home to New Yorkers whose jobs take them to Manhattan, but whose inclination has lured them to the distinctive neighborhoods of Brooklyn.

Brooklyn's destiny as a commuter suburb began early. In 1814, Robert Fulton's steamboats made it possible for New Yorkers to work in teeming Manhattan but live in the peace and quiet of Brooklyn.

In the years before the Civil War, many Manhattanites traveled across the East River on Sundays to hear Rev. Henry Ward Beecher preach against slavery at the Plymouth Church. After the war, Brooklyn became more openly competitive with its neighbor across the river. Olmstead and Vaux, who designed Central Park, also designed Prospect Park. Manhattan's favorite architectural firm, McKim, Mead and White, built the Brooklyn Museum.

The legendary Brooklyn Dodgers baseball team was formed in 1883. The Dodgers made baseball history when Jackie Robinson stepped onto the field in 1947—the first black man to play in the modern major leagues.

Although there are dozens of ways to get to the borough today, the true gateway to Brooklyn is the Brooklyn Bridge. The inspiration of John A. Roebling, built by his son and daughter-in-law, this was the first steel suspension bridge in New York. When it was completed in 1883, the bridge's massive Gothic towers dominated the city's skyline (up to that point, the tallest structure in New York had been the spire of Trinity Church on Broadway).

A Cow Grows in Brooklyn

Artist: Margaret Cusack
Patron: Emigrant Savings Bank
Location: Brooklyn Heights Promenade

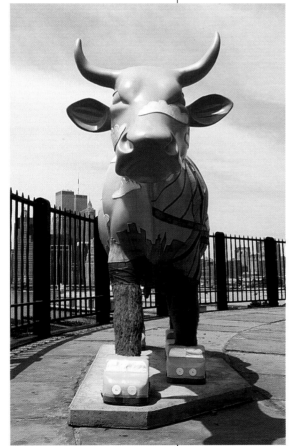

Sea of People Cow
(top left)

Artists: Victor Guan, student, with Mark Schwartz, art teacher, and Door students of OES/The Door, Alternative HS
Patron: BASF
Location: Cadman Plaza

Broadway Boogie Woogie Cow
(top right)

Artist: Yeshema Taylor of PS 244, School District 18
Patron: BASF
Location: Prospect Park

Brooklyn Bridge
(bottom left)

Artists: Traci Collier and Grade 6 students with Lynne Ames, art teacher of IS 55, School District 23
Patron: BASF
Location: Prospect Park

The Taxi Cow
(bottom right)

Artists: Alex Impagliazzo, Pam Foca, Bob Marinelli
Patron: KeySpan
Location: Metrotech Plaza, downtown Brooklyn

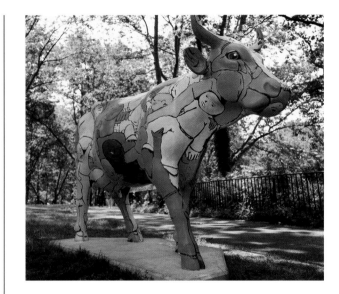

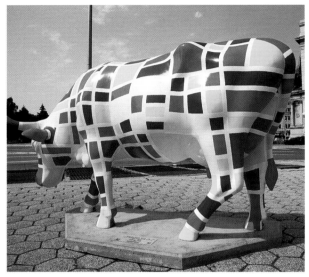

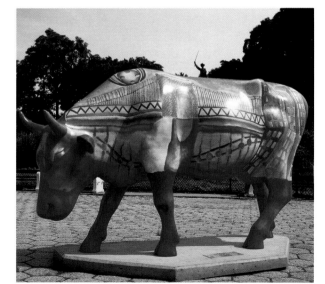

Queens

Queens is perhaps the most residential and welcoming of all the boroughs: some 36 percent of Queens residents were born in other parts of the globe. And Queens is home to Adriance Farmhouse, the last working farm in New York City, which survives as a museum in Floral Park.

Queens was largely rural until 1890, when industry began to settle in the borough. Yet Queens continued its farming tradition. Chinese-run vegetable farms in Astoria grew bok choy, bitter melon, and bottle squash for the restaurants of Chinatown. Large nurseries in Floral Park supplied flowers for the wholesale markets of Manhattan. It was only after the opening of Queensboro Bridge, which made the borough more accessible via automobile and trolley, that large parcels of land that had been agricultural were developed into residential neighborhoods.

Today the farms may have left Queens, but immigrants are still coming—primarily from China, Latin America, and the Caribbean. And since the 1990s, the borough has seen yet another wave of Irish immigration, ensuring that the melting pot still simmers.

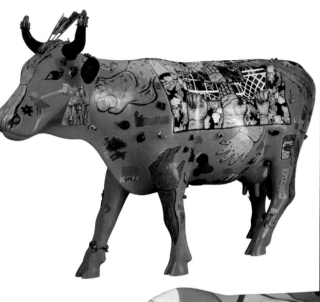

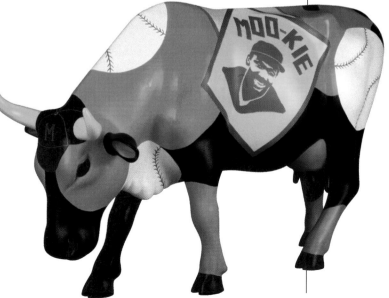

Sacred Cow #1
(top)

Artist: Sasha Chavchavadze
Patron: RCN Corporation
Location: Flushing Meadows–Corona Park, Flushing

The Moo-kie Baseball Cow
(bottom)

Artist: Janet Braun-Reinitz
Patron: CowParade New York 2000, Inc.
Location: Shea Stadium, Flushing

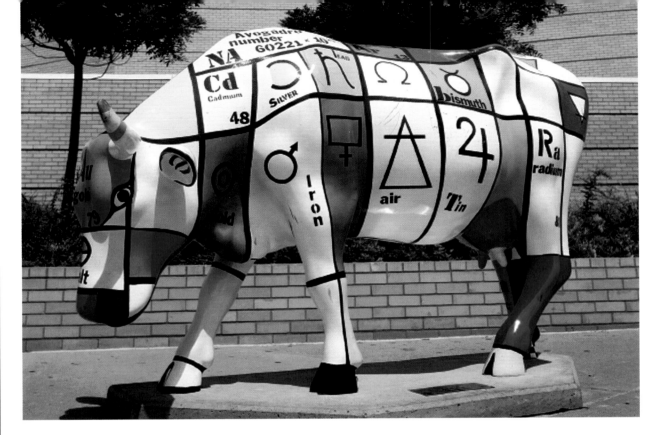

Cow Science

Artists: Colin Carew and
Jennie Booth, BooCrew
Productions
Patron: Pfizer
Location: Flushing
Meadows–Corona Park,
Hall of Science, Flushing

**HOLSTEIN
HALL OF
FAME**

Robthom Suzet Paddy
of Springfield,
Missouri, produced
59,300 pounds milk
in one year.

Colin Carew and Jennie Booth *Cow Science*

Colin Carew has painted sculpture before, but never a cow. Carew is a busy man—painter, poet, professional dancer, and DJ at a bar called Stingy Lulu's in the Village. His partner and collaborator, Jennie Booth, is also an artist who creates issue-oriented paintings and sculptures. "Her work is very aggressive," Carew said. "Sometimes it scares people who like their art to be a little glossier."

Carew and Booth's *Cow Science* is more intriguing than aggressive. It was inspired by a photograph Booth took of an antique periodic table of the elements she found on a wall in a village in Italy. Carew and Booth liked the look of the table. So did the people at CowParade. But by the time Carew and Booth's cow finally arrived, they had only two weeks to paint the beast. "We worked until 3 o'clock in the morning," Carew said. "We slept in the studio. It was an adventure."

The Bronx

The first European inhabitant of the Bronx was Jonas Bronck, who settled here with his wife in 1639. Legend has it that friends of the family who lived down in Manhattan would say, "Let's go up and see the Broncks." Thus, the borough got its name.

The first Europeans to see the Bronx were Henry Hudson and his crew on the *Half Moon*. During a storm in 1609, they sheltered in Spuyten Duyvil Creek. The Bronx was also a refuge, temporarily, for Ann Hutchinson, the religious dissenter who had been banished from Massachusetts and settled in 1642 along what became the Hutchinson River. Alas, she and all her family were killed by Indians.

Early on, residents of the Bronx expected that their community would be annexed by New York City. In 1868 the civic leaders of the Morrisania neighborhood numbered their streets so travelers could make a smooth transition from Manhattan to the Bronx.

The 1890s saw a huge influx of Italian immigrants. They landscaped the New York Botanical Garden and the Bronx Zoo and built the Jerome Park Reservoir. Skilled sculptors from Pisa who had moved to the Bronx carved the statue of Abraham Lincoln that sits in the Lincoln Memorial in Washington, D.C.

By 1934, the Bronx had the best housing in the five boroughs. Nearly 99 percent of residences had private bathrooms, 97 percent had hot water, and 95 percent had central heating.

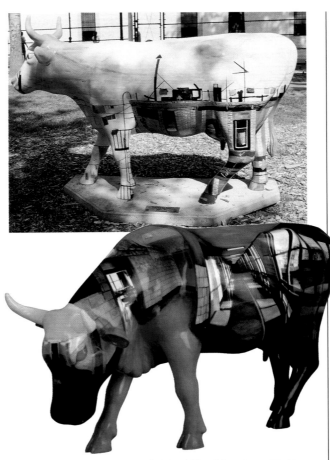

Sky, Buildings and Clotheslines
(top, two views)

Artist: Frank Leslie Hampton
Patron: CowParade New York 2000, Inc.
Location: Van Cortlandt Park, the Bronx

Smart Cow
(bottom)

Artist: Susan Leopold
Patron: CowParade New York 2000, Inc.
Location: Crotona Park, the Bronx

Liberty Cow
(top and bottom, right cow)

Artists: Michele Medina,
Anthony Spinello, Digna
Henriquez, of Port Richmond
High School, BASIS
Patron: BASF
Location: Wolfe Pond Park,
Staten Island

**At Moo York
via Staten Island**
(bottom, left cow)

Artist: Patricia Basirico
Patron: CowParade
New York 2000, Inc.
Location: Wolfe Pond Park,
Staten Island

Staten Island

Twenty-five years ago there were still dairy farms on Staten Island. Although it is considerably less rural today (lots of Staten Islanders blame the change on the Verrazano-Narrows Bridge), the island is still the most countrified of the five boroughs. It's also the most politically self-conscious: for years Staten Islanders have been threatening to secede from New York City.

The first native-born American saint, Mother Seton, was born on Staten Island. So was Cornelius Vanderbilt, who began his road to riches by ferrying freight and passengers between Staten Island and Manhattan (he borrowed the price of the boat from his mother; she made him pay it back). Later, Giuseppe Garibaldi, lived there during his exile from Italy.

Staten Island remained rural longer than any other borough of New York. In the early 1900s, when the farms were being divided into housing developments, real-estate promoters still accentuated the pastoral by advertising "Little Farms on Staten Island. . . A Quarter Acre for a Quarter a Day."

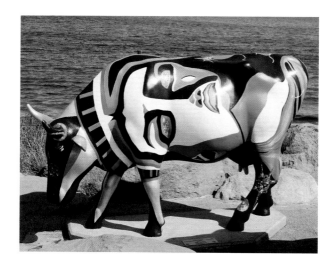

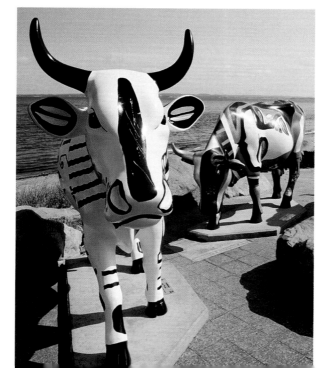

Richmondetta - Staten Island Cow

Artist: Lucy Sander Sceery
Patron: CowParade
New York 2000, Inc.
Location: Clove Lakes Park, Staten Island

Lucy Sander Sceery
Richmondetta

There were still cows in the neighborhood when Lucy Sander Sceery grew up on Staten Island. She remembers going to Sailor's Snug Harbor, a retirement community with its own farm, and seeing cows and chickens with the skyline of Manhattan across the harbor.

Richmondetta is Sander Sceery's salute to Staten Island "when it was still rural." The cow's markings are in the shape of the island. Around its middle is the Green Belt, Staten Island's famous stretch of protected undeveloped land that cuts across the middle of the island. You can see the Manhattan skyline in the cow's eyes and the waves of the harbor in its ears. Inscribed across the udder is "Hands Off the Gates," an injunction anyone who rides the Staten Island ferry will recognize.

Finally, on the cow's rump, "Where it belongs," according to Sander Sceery, is the Verrazano-Narrows Bridge, the structure that Staten Islanders love to hate.

DID YOU KNOW?

On average, a Holstein will be a good milk producer for 3 to 4 years.

COWMUTERS

Raqcow Welch

Artist: Chuck Barnard
Patron: Stamford Town Center
Location: Stamford Town Center

Stamford

In 1994 the city of Stamford and an enthusiastic group of corporate sponsors inaugurated the Stamford Sculpture Walk, an annual event that has brought fine art into public spaces. With that type of civic commitment to art in the open air, it was only natural that Stamford would welcome CowParade.

The emphasis on public art is only one facet of Stamford's renaissance. One hundred years ago, Stamford's major employer was the Yale & Towne factory, where locks were made. Today Stamford is a financial center, headquarters for a long list of prestigious corporations and home to hundreds of commuters who take the train to jobs in New York City.

Stamford is one of those rare cities that is at once urban, suburban, and rural. From the vibrant downtown it's only a short drive to the city's parks and beaches on Long Island Sound or to the beautifully wooded residential area of North Stamford. This is a dynamic, prosperous, forward-looking city that has not lost its amiable small-town feel.

KEY COW FACTS

A cow produces about 65 pounds of manure a day, 15 tons a year.

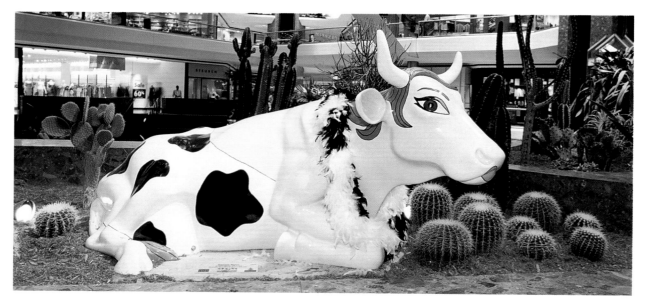

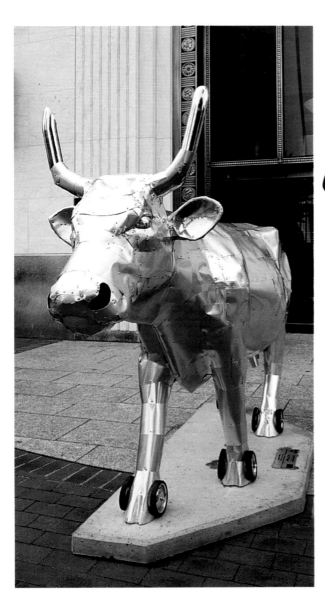

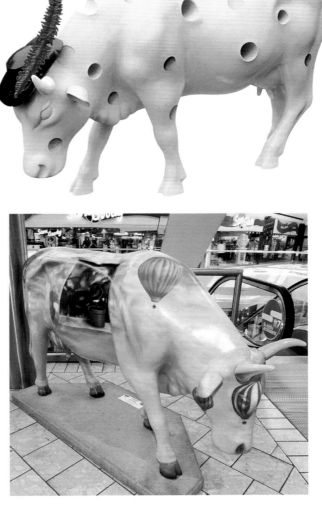

Canned Milk
(left)

Artist: Don Ervin
Patron: Clearview Investment Management Inc.
Location: Fleet Bank (at Atlantic and Broad Streets)

Holey Cow
(top right)

Artist: David Stein
Patron: First County Bank
Location: First County Bank (at Atlantic Street)

Plant Earth
(bottom right)

Artist: Mark Garro
Patron: Stamford Town Center
Location: Stamford Town Center

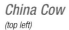

China Cow
(top left)

Artist: Angela Loeffel Burns
Patron: Clearview Investment Management Inc.
Location: Fleet Bank (at Atlantic and Broad Streets)

Baryshnicow
(top right)

Artist: Zora
Patron: F. D. Rich
Location: Landmark Square (at Atlantic and Broad Streets)

You Can't Have a Parade Without a ClOWn
(bottom left)

Artist: Marcele A. Mitscherlich
Patron: Avalon Communities
Location: Washington Boulevard at Avalon Corners

Bum Steer
(bottom right)

Artist: Jan Raymond
Patron: Taurus Advisory Group
Location: Veteran's Park (at Atlantic Street)

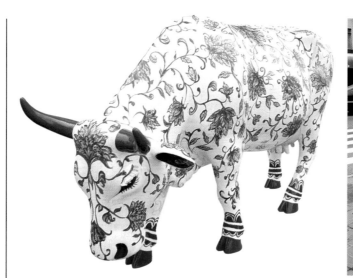

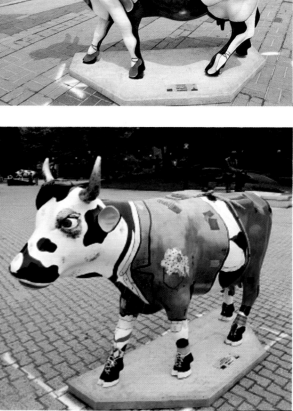

Mark Garro
Moother Earth/ Blue Mooon Under Milky Ways

As a fantasy illustrator for books by authors like R. L. Stine, Mark Garro is used to working on much smaller surfaces than the two cows he painted for CowParade. "I was also surprised when I came to work on the face of *Moother Earth/Blue Mooon Under Milky Ways*," he says, explaining that the sketches he had prepared for his cows only took into consideration the two broad sides. When he looked at the face, he was inspired to drape it with trompe l'oeil jewelry. When he stepped back from the cow, he realized that she had a kind of Hindu look to her. "I hadn't intended for that to happen. I guess it makes sense, given the cow's sacred status in India."

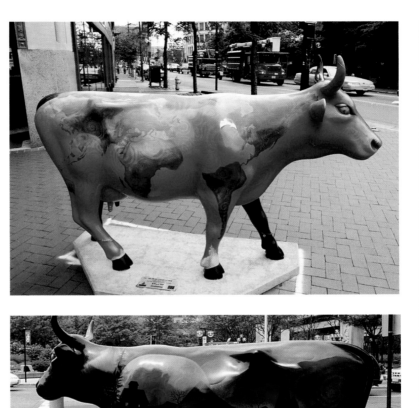

HOLSTEIN HALL OF FAME

Raim Mark Jinx of Cedaredge, Colorado, produced 60,440 pounds of milk in one year.

Moother Earth/Blue Mooon Under Milky Ways

Artist: Mark Garro
Patron: Stamford Health System
Location: corner of Main and Atlantic Streets

Twinkle Toes

Artist: Silvia Fernandez-Stein
Patron: Stamford Town Center
Location: Stamford Town
Center

Silvia Fernandez-Stein
Twinkle Toes

Silvia Fernandez-Stein is the coordinator of the urban arts initiative in Stamford. Born in Santiago, Chile, she began formal study in sculpture at the School of Fine Arts at the University of Chile before being exiled in 1976. In addition to teaching art, Fernandez-Stein is a dance teacher and choreographer. *Twinkle Toes* represents the combination of her love of dance and sculpture. Fernandez-Stein says that one of the most gratifying things about working on the project has been seeing people's responses to the cows. Children try to stand on tiptoe with their arms above their heads in the pose of the cow. And adults who find themselves looking at it at the same time end up talking to one another. "That to me," says the artist, "is the creation of a community."

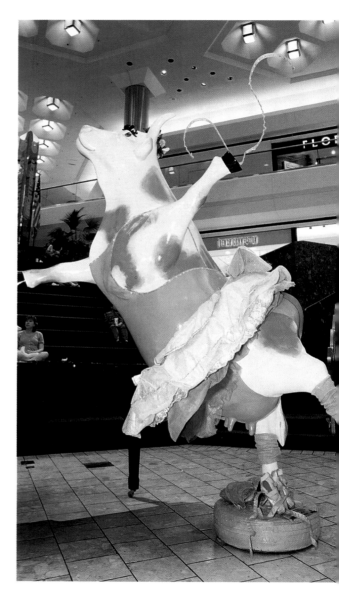

Bob Callahan's *Cowarium*

When graphic designer Bob Callahan learned that his cow was sponsored by The Kids Our Future Trust Fund, goldfish just leapt into his head. He says that when he thought of children he thought of school, and when he thought of school he thought of fish. Of course, goldfish have been swimming in his brain for a long time. Callahan was on the design team that created the original packaging of the Pepperidge Farm goldfish crackers in the 1960s.

Cowarium
(top left)
Artist: Bob Callahan
Patrons: Stamford Chamber of Commerce, The Kids Our Future Trust Fund
Location: 733 Summer Street

Cow...ch
(bottom left)
Artist: Matthew Burcaw
Patron: Stamford Town Center
Location: Stamford Town Center

Cowstruction
(bottom right)
Artist: Lisa Eisenman
Patrons: Turner Contruction Company and ACM Consulting Corporation; AMX Contracting Corporation, CGM Acoustics, Inc.; Cherry Hill Glass; Dupont Flooring Systems; IPC Information Systems, Inc.; Johnson Electric Company, Inc.; Mackenzie Service Company; Post Road Iron Works, Inc.; SRI Fire Sprinkler Corporation; Tri-Star Building Corporation; W.R. Johnson Company, Inc.
Location: Latham Park (corner of Bedford and Forrest Streets)

Lina Morielli *Miracles— The Special Delivery Cow*

Miracles was designed especially for its sponsor, the neonatal unit of the Stamford Hospital. With the help of artist Lina Morielli, babies who had been cared for in the unit and who are now growing and thriving painted the cow. The babies lent their hands and feet to print the cow: girls' handprints and footprints appear in pink; boys' appear in blue. The proceeds from the auction of *Miracles* will return to the neonatal unit so that more boys and girls will benefit from its services in years to come.

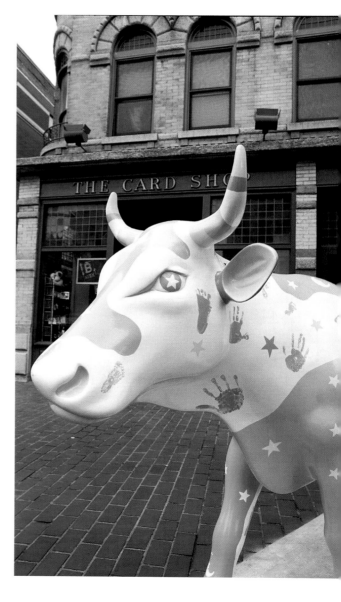

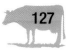

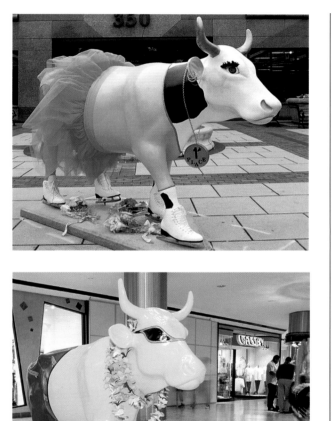

J. Cash Cow IV
(left)

Artists: Peter J. Cornell with Peter J. Cornell IV, Christina P. Cornell, and Denice Suriano
Patron: Taurus Advisory Group
Location: Veteran's Park (at Atlantic Street)

A Triple Sal Cow
(top right)

Artist: Nina Bentley
Patron: People's Bank
Location: People's Bank Plaza (at Bedford Street)

Cow-A-Bunga!
(bottom right)

Artist: Chuck Barnard
Patron: Stamford Town Center
Location: Stamford Town Center

Udderly Groovy
Lady Belle Bennett
(right and detail, below)

Artists: L. E. Murray and 77
painters, including patients,
families, and staff of the
Bennett Cancer Center
Patron: Carl & Dorothy
Bennett Cancer Center,
Stamford Health System
Location: Broad Street
(at UCONN)

L. E. Murray and
77 Painters *Udderly Groovy*
Lady Belle Bennett

Seventy-seven patients, family members,
staff, and volunteers of the Bennett Cancer
Center joined forces with L. E. Murray to cre-
ate this colorful, tie-dyed cow. Art has been
been an important therapeutic outlet for
patients at the center since 1993, when the
center's Expression Through Art Program
was established.

Udderly Groovy Lady Belle Bennett was a
very special project, instilling in all the partici-
pants a sense of camaraderie, cooperation, and
accomplishment. *Lady Bennett* made rounds
just like a doctor to visit the patients who
worked on her.

Rorschach Cow
(bottom left)

Artist: Mary Jo McGonagle
Patron: Clearview Investment
Management Inc.
Location: One Atlantic
Street (at the corner of
Broad Street)

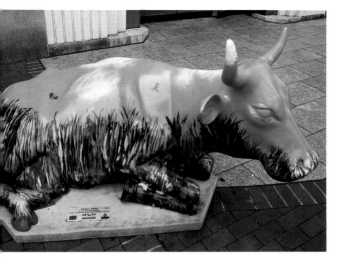

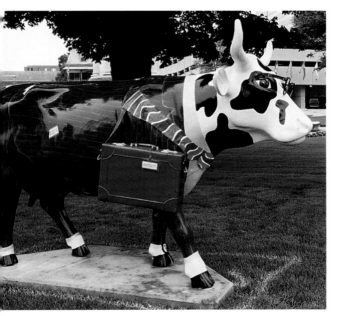

Pasture I. Zation
(top left)

Artist: Leon Chmielewski
Patron: Clearview Investment Management Inc.
Location: One Atlantic Street (at the corner of Broad Street)

Bumble Bee Cow
(right)

Artists: Roger Huyssen, Kit Campbell, Steve Garbett
Patrons: North Castle Partners Advertising and Silverman Realty Group
Location: Heritage Park (at Bank Street)

Cowmuter
(bottom left)

Artist: Jody Silver Schwartz
Patron: Robinson & Cole LLP
Location: St. John's Park (at the corner of Tresser Boulevard and Grove Street)

Ferg
(top right, left cow)

Artists: Bronz & Esposito
Patron: Frank Mercede
& Sons
Location: Ferguson Library
(at Broad Street)

Gus
(left and top right, right cow)

Artists: Bronz & Esposito
Patrons: Ferguson Library
Foundation; Clearview
Investment Management,
Inc.; Construction
Consulting Group
Location: Ferguson Library
(at Broad Street)

La Vida Mooca
(bottom right)

Artist: Lauren Valente
Patron: Equity Office
Location: 300 Atlantic
Street

Bronz & Esposito *Ferg* **and** *Gus*

Looking every bit as regal as their leonine counterparts in New York City, *Ferg* and *Gus* are the bovine guardians of knowledge at the Ferguson Library in downtown Stamford.

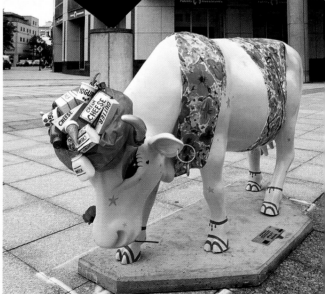

Sandy Garnett
Cow Print and
The Cow and I

Identity has always intrigued Sandy Garnett, who has been exploring the concept in the form of his fingerprint series of paintings. "Fingerprints," he says "are a labyrinth of personality. They are the mark of individuality, which has become an important idea in this high-tech time."

The fingerprint on *Cow Print* is that of David Bowie's thumb. Garnett has been soliciting the fingerprints of people he admires for use in his series and Bowie obliged. The piece is subtitled *David Bowie Contemplating Warhol's Cows* in reference to a series of silk-screened cows created by Andy Warhol.

The Cow and I is painted with an enlargement of the artist's own fingerprint. He liked the idea of blowing the print up so large that it became abstract and ended up looking a bit like a zebra.

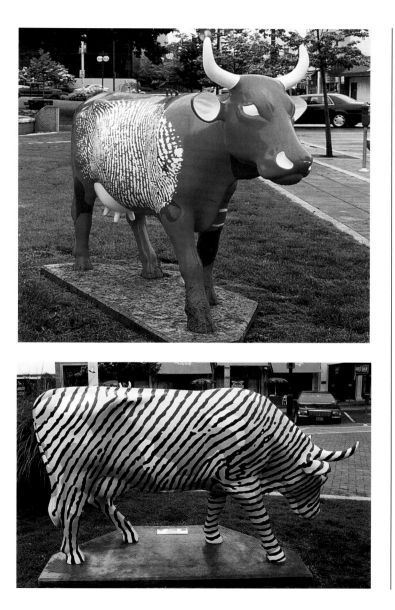

Cow Print
(top)

Artist: Sandy Garnett
Patron: Corcoran Jennison
Location: Columbus Park
(at Main Street and West Park Place)

The Cow and I
(bottom)

Artist: Sandy Garnett
Patron: Corcoran Jennison
Location: Columbus Park
(at Main Street and West Park Place)

DID YOU KNOW?

At birth, a healthy Holstein calf weighs about 90 pounds.

West Orange

Moona Lisa meets Moondrian

Artist: Robert Anderson
Patron: Reckson Associates Realty Corp.
Location: 200 Executive Drive

A hundred years ago, beautiful, bucolic West Orange was a resort town for the elite of New York City's Industrial Age. Located only 15 miles west of the city on two mountains, West Orange has since become a popular suburb for commuters to Manhattan.

Thomas Edison is perhaps West Orange's most famous citizen. Edison spent most of his life here and created the bulk of his important inventions in his factory in town. The first motion picture studio was developed on the grounds of his laboratory (now a historic site), which at one time employed as many as 10,000 people. In addition to the first movie studio, West Orange boasts the first planned residential community, Llewellyn Park, where Edison once lived. The park is a spectacular enclave of magnificent homes with superbly preserved properties that are still very much in use today.

West Orange has a herd of 28 beautiful cows that were wrangled by Mayor John F. McKeon and director of planning Susan Borg. It is the first small town to host a CowParade event.

"THE COW"
by Ogden Nash

The cow is of
the bovine ilk;
One end is moo,
the other, milk.

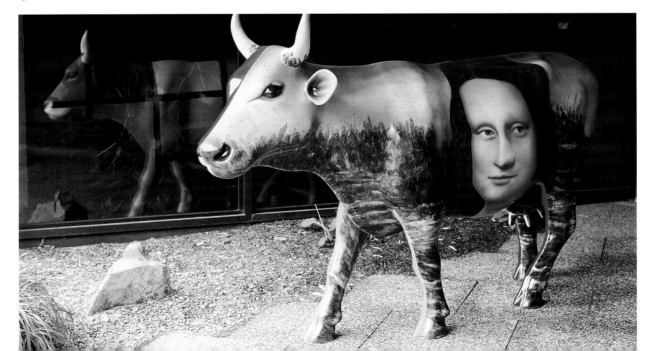

Punny Girl

So many puns about cows were flying around when the schoolchildren of West Orange learned the parade was coming to town that artist Ilona Kennedy thought it would be ideal to be able to use all of them. Cartoonist Jay Wecht came up with the idea of working the puns into separate cells so the cow would look like it's covered with comic strips. Eighty-nine children and 15 adults contributed to the cow, including the famous cartoonists Hy Eisman (*Popeye*), Jim Davis (*Garfield*), Jennifer Berman (*Caroline in the City*), G. H. Williams III (illustrator for *Batman* and *Green Lantern*), Mell Lazares (*Mamma* and *Miss Peach*) and Nick Humez (cartoonist for the *Star-Ledger*), as well as Mike Gordon from the rock band Phish.

The project involved much more work than Kennedy and Wecht had anticipated. The cartoon characters and speech bubbles were painted on pieces of canvas and then each element was cut out individually and placed on the cow. Kennedy explains, "We couldn't paste the whole rectangles of painted canvas on the cow because they tended to wrinkle on the curvilinear body."

Punny Girl:
A Cowtune

Artists: Ilona Kennedy, Jay Wecht, and Roosevelt Middle School students
Patron: Parmalat USA
Location: 347 Prospect Avenue, Essex Green Promenade

Icing
(top)

Artist: Herb Schwartz
Patron: New Jersey Devils
Location: 66 Main Street

Field Trip
(bottom right)

Artists: Michael Lindsay with West Orange High School students Felicia Soto, Margaret Walk, Valerie Termine, Sarah Shin, and Shawn Whelan
Patron: Organon Inc.
Location: 375 Mount Pleasant Avenue

Lightfoot
(bottom left)

Artist: Mark T. Smith
Patron: West Orange Plaza
Location: 345 Prospect Avenue, Prospect Avenue and Eagle Rock Park

Herb Schwartz *Icing*

The South Mountain Arena, home of the New Jersey Devils practice rink, is located in West Orange. Herb Schwartz, an artist who does signature work for Mattel as well as pieces for the White House, created the Devils's cow. Before being auctioned at the end of the parade, the cow will be signed by all the team members.

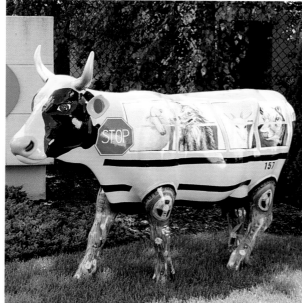

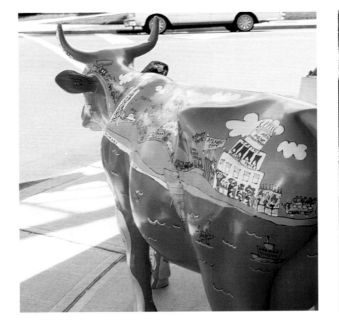

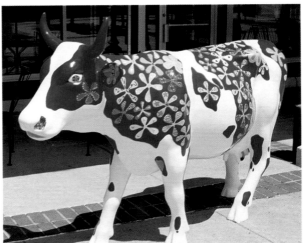

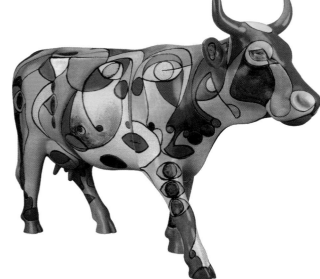

The Moo Jersey Cow
(top left)

Artist: Jenny Steinman
Patrons: CBL Fine Art, Crest Florist, Debby's New to You, Fortissimo Restaurant, Rascals Comedy Club, Walter Bauman Jewelers
Location: 459 Pleasant Valley Way

Peek-a-Moo
(top right)

Artist: Laura E. Chenicek
Patron: Llewellyn Park
Location: 1 Park Way, Main Street and Park Avenue

Cow Power
(bottom left)

Artists: Jenifer A. Kobylarz and Markus Baenziger with Edison Middle School students
Patron: Panera Bread
Location: 347 Prospect Avenue, Essex Green Promenade

Picowsso
(bottom right)

Artist: Tony Nogueira
Patron: Kessler Institute for Rehabilitation
Location: 1199 Pleasant Valley Way

Cowravaggio

Artist: Federico Castelluccio
Patron: The Manor Restaurant
Location: 111 Prospect Avenue

Federico Castelluccio
Cowravaggio

Few fans of the HBO series *The Sopranos* would guess that Federico Castelluccio, who plays Furio, the stony-eyed Neapolitan hitman, was trained as a painter. Born in Naples, Castelluccio, has lived in New Jersey since early childhood and got his B.F.A. at New York's School of Visual Arts. He showed his paintings in galleries in SoHo and elsewhere before trying his hand at acting.

This cow is a tribute to the Italian Renaisance painter Caravaggio. The left eye features a portrait of Caravaggio and a quotation from him: "Dipingere bene et imitar bene le cose naturali" (Paint well and represent well the natural world). In the right eye Castelluccio has painted a self-portrait and offered these words of his own: "Vi trasmetto tranite l'arte, il dono che Dio mi ha detto" (I give to you through art the gift that God has given me). In an allusion to the charity auction at which all the cows will be sold at the end of the parade, Castelluccio has painted a banner across the flank of his cow that bears the Latin inscription "Hilarem Datorem Diligit Deus" (God loves a cheerful giver).

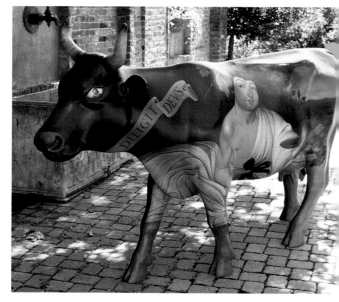

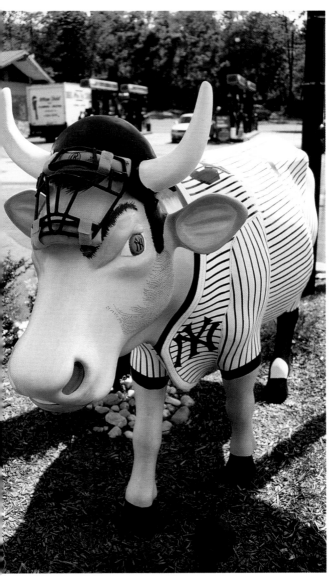

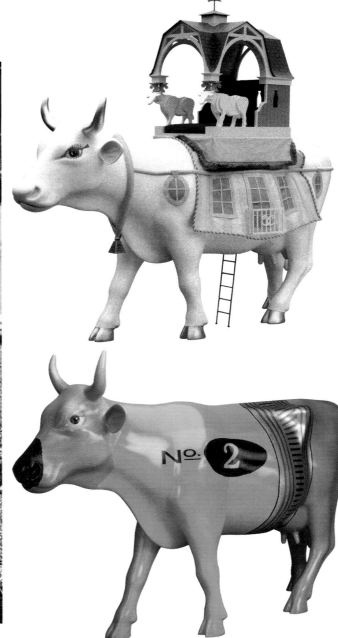

Moogi Berra
(left)

Artist: Herb Schwartz
Patron: West Orange Rotary Club
Location: 486 Prospect Avenue

Udderly Delightful
(top right)

Artist: Robert A. M. Stern Architects
Patrons: West Orange Public Library Sponsors: Bederson & Company, LLP; Mr. and Mrs. Anthony P. Massa, Jr.; McCumsey-Petry, P.C.; Sydell and Murray Palent; Rabinowitz, Trenk, Lubetkin & Tully, P.C.; Joseph A. Vena, Esq.; Robert C. Williams, Esq.
Location: 46 Mount Pleasant Avenue

No. 2 Cow
(bottom right)

Artist: Ellen Hanauer
Patrons: Matzel & Mumford and K. Hovnanian Company
Location: 555 Pleasant Valley Way

Lullaby Cow
(top left)

Artist: Beverly Sampson
Patron: K Mart
Location: 345 Prospect Avenue at Eagle Rock Park

Moonet
(top right)

Artist: Christina Saj
Patron: The Shauger Group, Inc.
Location: 347 Prospect Avenue, Essex Green Promenade

Angelicow
(bottom left)

Artist: Liz Lomax
Patron: Diener Mt. Pleasant Associates
Location: 471 Mount Pleasant Avenue

Amoorican
(bottom right)

Artists: Sam Park with Wilmans Auto Body Shop
Patron: Pathmark Stores, Inc.
Location: 345 Prospect Avenue at Eagle Rock Park

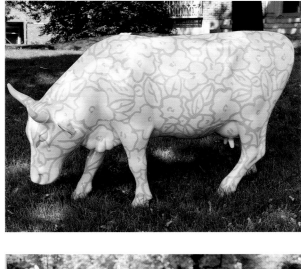

COW LORE

If a cow slaps her tail against a tree or a fence, bad weather is coming.

Art Decow
(top left)

Artist: Michael Graves, Architect
Patron: West Orange Arts Council
Location: 66 Main Street

The Edison Cow
(top right)

Artists: Irmari Nacht and Elisa Chalem
Patron: TAE Invention & Commerce Center
Location: 66 Main Street

Celeste Estrella Luna
(bottom left)

Artist: Chuck Miley
Patron: The West Orange Education Foundation, Inc.
Location: 301 Gregory Avenue

Moochas Caras
(bottom right)

Artist: Jose Cruz
Patron: Essex Green Shopping Center
Location: 347 Prospect Avenue, Essex Green Promenade

Edisonia
(top left)

Artist: Estrella Bianchi
Patron: The Atkins
Companies
Location: 101 Old
Short Hills Drive

Currency Cow
(bottom left)

Artist: Elyse M. Carter
Patron: PNC Bank
Location: 746 Northfield
Avenue

*The Black
Moooriah*
(right)

Artist: Anita Axelrod
Patron: Marriott Senior
Living Services
Location: 220 Pleasant
Valley Way

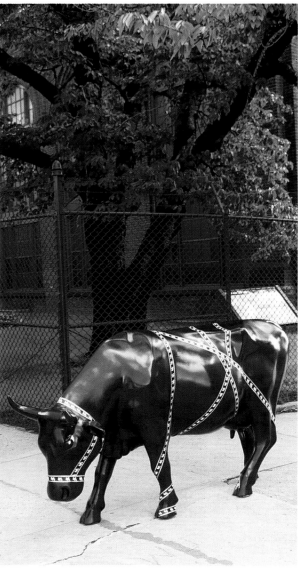

Nancy Pantirer
Ms. Moojestic

Ms. Moojestic looks remarkably like a statue cast in bronze. Artist Nancy Pantirer has created that effect by dipping synthetic fabric in a clear gloss medium and carefully draping it on the cow. As the fabric dries, its color darkens and it hardens, which means that Pantirer had only one shot at getting the draping right and that she had to work very quickly. After the fabric dried, Pantirer painted the sculpture with metallic acrylics to give it that bronzed look.

West Orange Police Chief Jim Abbott takes the bull by the horns.

Ms. Moojestic

Artist: Nancy Pantirer
Patron: The Point at Crystal Lake
Location: 347 Prospect Avenue, Essex Green Promenade

INDEX OF NEW YORK SPONSORS

INDEX OF NEW YORK ARTISTS

INDEX OF NEW YORK SCHOOL ARTISTS

INDEX OF STAMFORD SPONSORS

INDEX OF STAMFORD ARTISTS

INDEX OF WEST ORANGE SPONSORS

INDEX OF WEST ORANGE ARTISTS

PHOTOCREDITS

JUDAH HARRIS: *A la "Moo"tisse p.58, Afro Cow p.73, All the Moos that's Fit to Print p.51, Bess Bovine p.70, Blue Moo p.74, Broadway Baby p.56, Cabbie Cow p.47, Checker Cab Cow p.49, Checkers The Taxi Cow p.47, Circuit Cow p.94, City Cow p.70, Cow Ticker p.58, Cow Word p.89, Cowlage p.68, Cowleidoscope p.59, Cows of Hearts p.73, Cubist Cow p.68, Daisy in the Meadow p.28, emoo.cow p.93, Graylene p.37, Harem in Heifer p.94, I Cow p.53, La Moochachka p.50, La Vie Bovine p.57, Milk? p.29, Moo Jersey Diner p.46, Moo York, New York p.68, Moobile Library p.60, Mooving on Up p.84, Moozo the Taxi Cowb p.68, NAM Cow p.57, NYC Summer Fashion p.79, On the Moo p.49, Orchid p.101, Pixel Cow p.67, Rakow p.84, Sight Steer p.67, Streetsmart Cow p.58, Super*

TaxiCow p.49, Taxi Cow p.46, Taxi Cow p.57, The Big Apple Cow p.69, The Cow That Wants to be a Horse p.93, The Hay-Team p.67, Times Square Cow p.45, Wrestler Cow p.70.

SCHECTER LEE: *A Cow Grows in Brooklyn p.113, A Walk in the Pasture p.50, American Flower Power Photo Cow p.5, Amoozon Rainforest p.75, Big Apple Cir-cow p.50, Big Apple Cow p.65, Broadway Boogie Woogie Cow p.114, The Bronx Is Up, The Udder Is Down p.26, Brooklyn Bridge p.114, Ceci n'est pas une vache p.29, Collaborative Hand Quilt p.21, Combination of All Things p.54, Cow Friend's Network p.5, Cow Hide p.73, Cow Science p.116, Cowabunga p.10, Cow-Ider for the*

Mooseum of Modern Art p.20, Deft-Tiled Cow p.22, Dottie p.13, Edu-cow-tion p.55, Fresco p.26, Greenhorn in the City p.12, Harbor Park p.12, Herd on the Street I: Moo-la the Cash Cow p.8, Herd on the Street II: Blue Moo-n p.8, Herd on the Street III: Ella Mae, the Cow Cow Boogie Cow p.8, Herds'n River School p.30, Holy Cow p.35, Housing p.54, Jet Set Tony p.4, Liberty Cow p.118, Live Stock p.7, MooMA p.54, My Parents' Cow p.63, New York State of Cow p.4, Picowso p.28, Picowsso p.23, Precision Cow p.43, Rakow Warrior p.72, Roebling Wire Rope Cow p.13, Sacred Cow #1 p.115, Sacred Cow #2 p.112, Save the Moosic p.31, Sea of People Cow p.114, Swiss Wine p.3, The Early Show p.28, The Moo-kie Baseball Cow p.115, The Sounds of Moosic p.4,

PHOTOCREDITS CONTINUED

Cow silhouettes throughout by John DeSalvo with CowParade Graphics Corporation